LEARN SOMETH...

CALLIGRAPHY

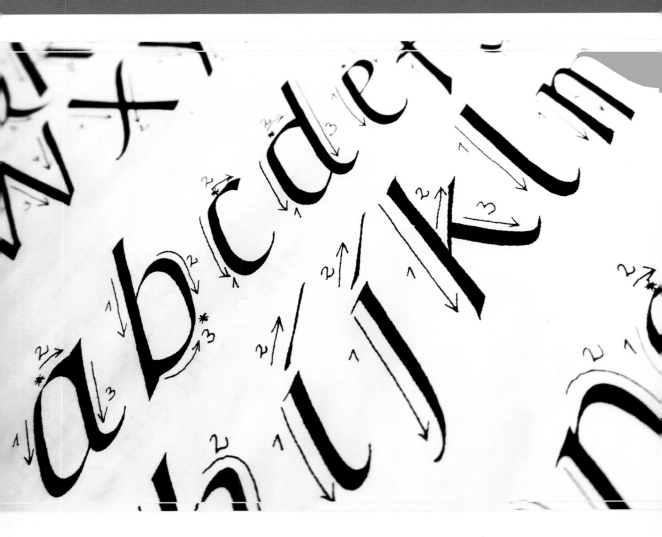

pil

Publications International, Ltd.

CONTENTS

INTRODUCTION

Calligraphic styles are as numerous and as varied as musical styles, and—as with music—the student must master the basics first. A music student is not expected to learn the guitar and the double bass at the same time. And you will not be confronted with a bewildering array of quills, pens, and brushes. All you need to begin calligraphy is one broad-nib fountain pen; this will be your only tool when you practice with this book.

As you start to study calligraphy, your first undertaking is to master a simple alphabet of minuscules, or small letters. Then you study the majuscules, or capital letters, which are compatible with the small letters. (The words *minuscule* and *majuscule* are derived from Latin for "lesser" and "greater.") Then, once you've mastered the Arabic numerals and a few odds and ends of punctuation and symbols, you'll be able to write anything you like in a correct calligraphic hand.

After that, you can start thinking about adding some freedom and virtuosity to your style with flourishes and ornaments—the frosting on the cake. But don't be in too much of a hurry. If you rush through the earlier chapters of this book, you will cheat yourself. Frosting won't save a bad cake, and flourishes won't compensate for lack of control.

So take your time. You'll never regret the time you spend learning to make each letter properly and beautifully. And it does take a little time, because you need to develop many new and unfamiliar habits; you'll also learn to hold your pen properly—if you don't do so already.

When you begin to work with this book, be kind to yourself. Don't expect that your present handwriting, with all its long-established shortcomings, will give way over-night to a perfect calligraphic hand. Continue to write as you always do for everyday purposes, and think of learning Italic as a completely separate activity.

So write your grocery list or your office memo in your ordinary hand and with your usual pen. Never write Italic with any instrument except your broad pen, and when you pick up your broad pen, write only Italic.

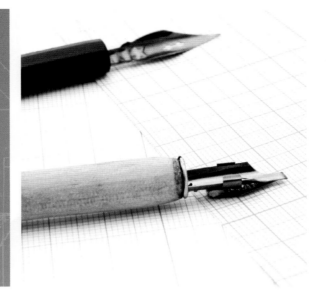

After learning the Italic style, which can be written in at least three basic modes of varying degrees of formality, you will have good control and an understanding of what the broad pen can do. At that time you will be able to move on with relative ease to Uncial and Gothic and many, many more styles and their unlimited variations.

Keep in mind that calligraphy, despite its discipline and formal appearance, is handwriting, not lettering in the usual sense. As a student scribe you should use the correct terminology relating to your work. This book teaches a highly developed form of *writing*, not printing. None of the letters that will be described here were *printed* in their original form, and you are not learning to *print*. Printing is done by an impression, as with a press, a rubber stamp, or a typewriter. The making of letters by hand is *writing*, no matter how carefully constructed they are.

Having made that distinction, however, you may, as a brand-new student, find it helpful to make another distinction and think of your calligraphy not as writing but as *drawing*. This will help you keep your everyday writing style separate from your broad-pen work. In calligraphy, each stroke and detail must be deliberately *drawn* to avoid falling into writing patterns you have been repeating as a matter of habit for many years. So, for now at least, train yourself to think of drawing the Italic alphabet that you will learn in this book.

A word or two about how this book is structured. The instructions on how to make each letter are seprated from your worksheet or practice area. Some calligraphy books present model letters with practice space right alongside; this book does not do so for a very good reason. Calligraphy requires that you train your mind and eye as well as your hand and pen. You must be able to see the characters in your mind's eye and

project them onto your page. You cannot do this if you have the model in front of you; the model stays on the paper, instead of in your memory where it belongs. The *Rule of Letters* that follows explains this system of study.

Except for basic guidelines, this book also avoids the use of props like grids and graphs. Again, this will make it easier, not harder, for you to develop skill and confidence. Your aim is to develop a style that is technically correct but also lively and individual. And if you rely too heavily on graphs and grids when you begin, you will find it difficult to break away from them later.

By the same token, you will find words in this book written in other languages—usually Latin or Italian. If you're unfamiliar with the meaning of the words, you're more likely to concentrate on their shapes, and that is what you must do in order to duplicate them correctly.

The Rule of Letters is presented in the next pages. Following that, you will find a thorough discussion of the scribe's equipment (there isn't much of it, but correct choices are important) and environment. This is followed by information on using the pen, pen strokes, and letter forms and construction. Then you are introduced to two alphabets—the Italic small letters or minuscules, and the Roman capital letters or majuscules—plus numerals, punctuation, and common symbols.

The later pages of the book are devoted to more advanced details such as joins and double letters; solutions to common problems; variations on the basic alphabets; flourishes, ornaments, and color theory; and page design and layout. Then come suggestions and plans for beautiful ways to use your newfound art to make monograms, invitations, announcements, personal stationery, bookplates, labels, and other delightful projects.

By the end of the book you'll be in command of an exciting new skill and ready to progress to new alphabets.

THE RULE OF LETTERS

The way in which you study is at least as important as the time and energy you spend studying. In order to keep on a truly productive course, you are advised to adopt the method explained here. It will help you to discipline both yourself and your pen and to resist the natural tendency to try to do too much too soon. You will be rewarded by steady progress in your new skill.

Look at one good model of a letter that you know to be made by a disciplined and skilled calligrapher. Depend on the best instruction available. This book is your present standard; later you may decide that you would like to take classes from a teacher with a good background in calligraphy. At the beginning, choose only a simple example of each letter. Stay with this one character for the time being and concentrate on it. Don't overload your ability.

Look Try Examine Turn

Study your model for several minutes, with extreme attention to every detail. Examine every line, loop, and change of direction, and study the overall proportions of the letter until you can describe it fully in words. Turn the model over so that you can't see it, and repeat the verbal description with your eyes closed or fixed on the blank paper or a wall. Did you really get an accurate mental image? Repeat this exercise until the answer is yes.

Now try to draw the letter. Describe the letter again slowly and deliberately as you execute it on paper with your pen. You don't have to swing through it with grace—just trace out the image you tried to commit to memory. It doesn't matter if it's angular, stiff, or irregular at first. Follow the skeletal track of each letter. (Letter skeletons are explained on p. 49.) Smoothness and grace come gradually, but failure to follow that correct skeleton will destroy the validity of any Italic letter, however smoothly and confidently made. You only need a few attempts to determine how effective your study of the letter has been, and two or three tries will no doubt reveal to you several details that you're unsure about. It is absolutely necessary that you *not* look at the model while making these trial characters. The whole purpose of this exercise is to make you independent and force you to become a detective—a scribe who can find the tiniest clues that show how a letter is properly formed. Now turn back to your master model of the letter in question, and fill in the blanks in your memory that were revealed by your attempt to make the letter. Compare your letter with the model all

you like. Make up your own names for the shapes and effects you want to duplicate, and use them to help your memory. Some of the terms used in this book—for example, bird's head, squeegee stroke, ice-skate stroke, and so on—are the author's own inventions. They will help you, too, to understand and remember how letters are made.

Now hide the model and try to improve on your first attempt. Again, it will only take a few tries to show you how much you've learned and which details still elude you. Thus, the whole cycle repeats.

This method of self-teaching, faithfully observed, will work for any letter, minuscule or majuscule. Stay with one letter at a time until you achieve *success*. Success means improvement, not perfection, but you are wasting your time and effort if you slack off before any noticeable improvement takes place. A little today, a little tomorrow or next week, will eventually lead to excellence if you keep it up. You should always keep your work "plastic." That is, it should never become set and inflexible at any one stage, but should always be alive and growing.

Even if your model later proves to have been inferior, or even wrong, this self-teaching system will be constructive. Its main purpose is not to teach specific characters. Its real, and much more important, purpose is that you should learn how to look and imitate and learn. Books and teachers are only guides. The real teaching is done by you alone. Once mastered, this method of self-instruction will forever be of use to you, even when working with an instructor.

Examine

Repeat

Success.

THE SCRIBE'S EQUIPMENT

In order to learn as much as possible from this book, you must have the correct tools. Calligraphic supplies from a number of manufacturers are easy to find at very modest prices—but their quality is not always as high as you might like. Also, salespersons sometimes unwittingly recommend the wrong tools to beginners. For example, certain very fine, expensive drawing-pen inks used by professional artists are absolutely useless for calligraphers and may even harm your fountain pen. Calligraphic materials that perform properly are essential to your success; the following suggestions should guide you when selecting your pens, inks, and papers.

Later, you may wish to invest in more varied and expensive equipment, but to start with, you probably only need to buy a pen, ink, and a pad of bond paper. If you have some bond paper in your home already, you may not even have to buy paper. But be sure to read about paper selection and evaluation on p. 19-21. Of course, for starters, you already have the worksheets in this book.

A pen is your first and most important requirement. Most students of calligraphy, as well as most professionals, use steel-nibbed pens shaped like the original quills and reeds that were cut by hand for writing in former times. The word penknife is a relic of those days, when anyone who wrote had to prepare and maintain fragile quills and reeds that needed frequent and skillful resharpening. Modern dip pens, which—as the name suggests—you must dip into the ink, are today's version of these traditional writing instruments. It's more likely, however, that you will use a fountain pen.

The modern fountain pen, with its steel nib and a reservoir to hold the ink, allows you to write anytime, anywhere, without access to an ink bottle. A fountain pen requires very little maintenance; you don't even have to worry about fragility of the nib. You must, however, develop the habit of only uncapping the pen just before use and recapping it immediately when you stop writing. Unlike a ballpoint pen, a fountain pen will rapidly dry at the tip and fail to start if it's left uncapped.

The Roman alphabet, among others, was traditionally written with a cut quill or other broad-edged instrument. A thick-thin character that depended upon direction of the writing stroke rather than pressure was developed. The Italic hand demonstrated in this book clearly shows a contrast between thick and thin letter parts. These ariations are automatically imparted to the forms, without anipulation or extra effort. Your broad pen, a modern steel replica of the original goose quill, does it all if you make the correct basic shape of the letter. This modern fountain pen has a reservoir that permits long periods of uninterrupted writing.

To complete the worksheets in this book, you should use a pen with a nib proximately 1.3 mm broad. Unless the height of the letters is readjusted proportionately, a narrower nib will produce slender, more extended-looking writing; a broader nib will produce fat, blacker-looking writing. To a very slight degree either effect is acceptable, but the least bit of excess is fatal.

Here are the names of just a few popular fountain pens designed for calligraphers. They are not expensive, and at least one of them should be available in your neighborhood. Many of these pens can be fitted with nibs specifically designed for use by left-handed scribes. Special techniques for left-handed calligraphers will be discussed in the following chapter. Interchangeable nibs of various widths are available to use with all the pens listed. A selection of dip pens is also given.

FOUNTAIN PENS

SHEAFFER

Sheaffer's NoNonsense® fountain pen is loaded with cartridges—neat, but a little more costly than using ink straight from the bottle. Also, of course, this means you must use Sheaffer inks unless you're ambitious enough to reload the cartridges with a syringe. Three nibs (fine, medium, and broad) and a selection of different color ink cartridges come with the pen. These pens are also inexpensive. Other more expensive sets are also available. Sheaffer does not make nibs for left-handers. The Sheaffer pen is more free-flowing than the Platignum (discussed below) but can still be used for formal Italic writing.

PLATIGNUM

This British manufacturer makes fountain pens with standard or petite barrels. Seven nib widths range from extra fine to B4 and all nibs are interchangeable with both types of barrels. Special nibs for left-handed scribes are available in most sizes. These pens are not expensive. The Platignum pen is excellent for formal Italic, and the moderate ink flow gives very good thin strokes. A Platignum lettering set is available and includes nibs in six sizes. (Osmiroid fountain pens, also made in England, come with a similar range of nib sizes and may be carried by some suppliers in place of Platignum.)

DIP PENS

BRAUSE

These pens have excellent-quality steel nibs with controlled reservoir flow. The nibs are slightly canted, to the advantage of right-handers. An inexpensive set includes nine nibs of different sizes. The pens feel somewhat stiff in use.

MITCHELL ROUNDHAND

These pens have excellent-quality steel nibs with controlled reservoir flow. The nibs are slightly canted, to the advantage of right-handers. An inexpensive set includes nine nibs of different sizes. The pens feel somewhat stiff in use.

SPEEDBALL

These American pens come in a variety of nib widths and are available at most art stores. However, only the two broadest sizes are recommended for your use.

INKS

Selecting an ink is trickier than it sounds. Just any ink won't do. Inks are formulated in many ways for many uses, and the purpose for which you plan to use an ink must be considered carefully before a choice can be made.

First of all, the calligrapher requires a black ink. Black is in keeping with tradition because it looks best against the traditional white surface; and scientists have found that black on white is also the best possible combination for legibility—with the exception of the impractical combination of yellow on black. Next, the calligrapher requires an ink that will flow freely and not clog the fountain pen.

Third, the ink must cover well. This means that, like good wall paint, it should be so strong and dense that only complete blackness can be seen where it is applied. There should be no inked places that are more (or less) pigmented than others, and no additional blackening where two strokes overlap or cross one another.

Ideally, the ink should also be waterproof, but this is not expected of ink required to flow in a fountain pen. Waterproof black ink or India ink is not suitable for use in a fountain pen and will clog the nib immediately, necessitating careful cleaning with a commercial ink solvent or a household ammonia solution.
All inks can be diluted with distilled water (refrigerator frost is a serviceable substitute). It's sometimes necessary to dilute a colored ink that has evaporated in the pen and looks too dark. When you use colored inks, the colors should always be bright and brilliant to contrast with and liven the blacks. Generally, for traditional and esthetic reasons, blue-black and sepia inks are not recommended. Since this book describes ways to use color, several kinds of colored inks, with comments on each, are included in this section.

Several tried and true inks are listed here for you to choose from. If you experiment, you may discover good qualities in other products or even find that an ink not listed here is especially to your liking. You may also find an unsatisfactory product, which will help you understand why these inks have good recommendations.

PELIKAN

This German company produces the 4001 series of fountain pen inks that includes excellent black and blue inks. (Blue-black is also available, but the author does not recommend it for calligraphic use.) The 4001 red is a fiery vermilion—a fountain pen red that's superior for calligraphy to any other red the author has used. These are very free-flowing inks made of dyes. Pelikan also produces an ink called Fountain India, which, despite its name, is *not* an India ink. This is probably the densest black ink that you can use in a fountain pen, and therefore the grittiest and slowest flowing. It produces excellent hairlines in formal Italic writing.

HIGGINS FOUNTAIN INDIA

The name of this American ink is also misleading, since it's not an India ink. It is, however, an excellent ink for writing. It's water-soluble and very vulnerable to moisture, in spite of which it can stain your fingers and clothes and should be handled with care. Because this ink is vulnerable to abrasion as well as humidity, erasing pencil guidelines can be a hair-raising experience. For permanent work, you'd be wise to choose another ink.

HIGGINS ETERNAL BLACK

This is a very black ink with medium flow.

SHEAFFER

This American ink is available in cartridges for use with the Sheaffer NoNonsense® pen. Among the Sheaffer colors are black, (dark) red, (deep) blue, and green. All these colors are excellent except for the red, which looks muddy when juxtaposed with black. Some Sheaffer inks are also available in bottles.

WINSOR-NEWTON INDIA NON-WATERPROOF

This ink, made from Chinese stick ink, is probably the blackest ink that comes in a bottle. It's very gritty and not suitable for fountain pen use, but it's excellent for dip pens.

PAPERS

The variety of papers available is as bewildering as all the pens and inks combined, and it is the element over which the scribe has the least control. The calligrapher is often required to work with papers that were selected for their economy, texture, color, or excellence for taking printed images. Even "calligraphy papers" sold by artists' suppliers and by pen manufacturers in calligraphy kits are often far from satisfactory. For these reasons, you should experiment with all kinds of papers on your own. By comparing papers and eliminating the unsuitable ones, you will soon become a good critic of papers. Skill in evaluating papers is part of being a competent scribe, so begin right now by noting the following tips as a foundation for developing your calligraphic judgment.

- White, or nearly white, is traditional and preferred.

- Coated (glossy) papers are bad because the ink floods and the clean lines of the letters are destroyed.

- Paper with an appropriate writing surface need not be expensive.

- Rag paper and expensive artists' papers and boards are more durable than other papers and best permit erasures and corrections.

- Attractively packaged "calligraphy pads" are not necessarily good. Usually they are just costly. Some of them, in fact, are very disappointing.

- Cheap papers sometimes have very adequate surfaces for good writing; even some brown wrapping paper and some manila envelopes are workable, at least for practice.

- Bond paper is usually acceptable, but bond papers vary, too.

- Some papers may work well with one ink and not with another, so don't jump to conclusions without sufficient evidence.

- Temperature and humidity affect paper considerably. The way a particular paper takes the ink in a dry, heated house may be very different from its performance under humid conditions.

- Bleeding may be caused by porosity of the paper, by high humidity, or by an emulsifying quality of the ink.

- The freeness of the ink flow to the nib is another factor. The ink will flow less freely if you write on a sloping board with the pen barrel held nearly level.

- Remember to select a translucent paper if you want to write along lines ruled on a slip sheet placed under your writing paper.

- If possible, before investing in a paper, test a sample with your own pen and the ink you intend to use.

THE FOLLOWING PAPERS ARE WIDELY AVAILABLE
IN ARTISTS' SUPPLIES STORES AND STATIONERY SHOPS.

STRATHMORE 300 SKETCH

This paper is available in kid finish or textured finish. Both offer a good writing surface. The paper is very durable and strong, and heavier weights are available.

CRESCENT BOARDS

Crescent's "illustration" and "colored drawing boards" are suitable for pen and ink. They have a good writing surface and are stiff enough for large placards, etc. Crescent makes these boards in a variety of colors, qualities, weights, and textures.

HAMMERMILL DUPLICATOR PAPER

This paper is available through office supply stores, but is often sold in fairly large quantities. Caution: You can only write well on one side of this paper. The watermark must be legible from the writing side.

The following are all recommended for their low cost for use as practice paper as opposed to art paper.

STRATHMORE BRISTOL 3-PLY ARTISTS' PAPER

This paper has a toothy surface, good for very deliberate formal Italic and fine hairlines.

NEKOOSA BOND

This paper has a medium surface; it's excellent for practice and not expensive.

PAPER FOR PENS

A very smooth surface—better for thicker inks.

OTHER EQUIPMENT

You will, of course, need a table to work on and a seat. The chair, stool, or bench need not have a back but should be of a comfortable height for your size and allow you to address your work with your hands, forearms, and elbows on the table in the position illustrated on p. 27. The table should be firm and stable and clear of clutter.

You will eventually want a soft lead pencil (HB or #2, or softer) and a ruler for preparing guidelines. The pencil should be very sharp, so you'll also need a mechanical pencil sharpener or piece of sandpaper. You should also have a piece of art gum or a kneaded eraser to remove your guidelines and margin rules from the finished work. If you have a T-square and a plastic triangle, they will be very helpful in laying out your work before beginning a piece of formal writing. Artists' fixative in a spray can may be used to set your water-soluble ink and make it more durable. Use the fixative with great care. A spattering spray or too much spray can ruin a beautiful piece of calligraphy. Most artists' and calligrapher's suppliers stock all these items.

When you've developed more skill, you'll find it helpful to use a slanted writing surface instead of a flat table. Traditionally, and professionally, the sloping surface has been used to overcome the effect of gravity on the flow of the ink, especially when using dip pens. With the writing surface sloping at about 45°, the long axis (barrel) of the pen can be held almost level, i.e., horizontally. This means that gravity won't cause excessive ink flow, so that the writer can control blotting or flooding and can make thin lines that are very fine and "dry" looking.

Use of a sloping surface is not recommended to the beginner, because the modern fountain pen can be used quite satisfactorily on a flat surface. Even a fountain pen, though, will function more sensitively if held horizontally, so later you may want to use a drawing board on an easel. This arrangement can be constructed easily and stored compactly when not in use. When you do decide to try working on a sloping surface, be sure that your board is smooth and firmly braced, and that it has a cleat at the bottom so that it can't be pushed back as you write. Your writing surface must be stable and rigid or your work will suffer.

THE SCRIBE'S ENVIRONMENT

Calligraphy is a fine art and demands all the self-discipline required of musicians and painters. When you plan to begin practicing, be sure all children, pets, and television sets are under control so that you will not be interrupted or distracted. Furnish yourself with plenty of light, and clear enough space on a solid, smooth table to allow you to place both hands, forearms, and elbows on it without being cramped or crowded. A little music might help put you in a creative or artistic mood.

A sloping surface is preferred for finer work, but a drawing table or similar piece of large equipment is not necessary for beginners, especially when using a fountain pen that flows consistently at a steep angle on a level surface.

Because both forearms *and both elbows* must be supported by the table surface, you must sit up close to the table, and you can't do this comfortably unless your chair or stool is high enough. This elbow position is a *must*. You cannot do smooth work unless your arms are supported. You'll really understand the importance of this later, after you develop some skill. For now, accept it on faith and establish the habit of assuming the correct posture every time you write.

NOTE: Left-handed scribes simply use a left-oblique nib and reverse this hand position.

Unless you are left-handed—in which case there are special instructions for you later in this chapter—use your right hand to hold the pen and the left hand to hold the paper. Your left hand, however, should be used not just to keep the paper from sliding as you write, but also to hold it flat. A writing pad has considerable resilience, or bounce, partly because of the air layers between the sheets. Also, the top sheet may "crawl" under the sideways movement and pressure of the pen. So your left hand must also compress the sheets in the writing area to prevent this tendency to crawl. To be effective, you must keep your left hand very close to the area where the pen nib is working. The diagrams show two recommended positions for the left hand.

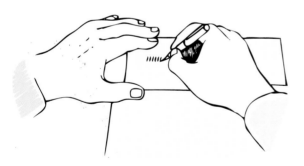

Standard position of the hands, showing how the left hand secures the writing paper and the slip sheet. The slip sheet is positioned well below the writing line.

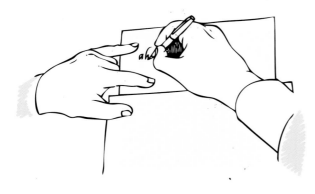

An alternative position for the left hand. This position is favored by the author.

Your sheet or pad of paper may be placed square with the tabletop or slanted slightly to the left (counterclockwise). Whichever position you prefer is okay, but when you decide the angle that suits you best don't vary it. If you keep changing the position of your paper your writing slant (and other features of your work) will lack consistency.

The table on which you work should be cleared—or at least organized. Books, papers, keyboards, pencils, etc., must make way for you. There should be no loose books, papers, or notes under your writing pad. Too often, a student scribe will try to practice in a cramped position at a cluttered table without realizing that things are imposing restrictions on the work. (Imagine a watchmaker trying to work with someone bumping into him all the time.) Beginning now, develop the habit of taking charge of the situation and organizing everything to your advantage. Experiment to find the arrangement of your supplies that is most convenient for you.

Before you begin to write, place several sheets of writing paper under the one you're going to use. This makes a good cushion against irregularities in the tabletop. (Writing on a pad of paper serves the same purpose.) The cushion effect also makes the writing proceed more moothly because the entire chisel edge of the pen nib will contact the paper under quite moderate pressure. This helps to make clean, crisp beginnings and also allows the ink to begin to flow immediately.

The cushion effect also helps equalize the pressure of the pen nib. A pen held incorrectly, so that one corner of the nib (usually the left one) is under slightly greater pressure than the other, may produce broad strokes that are sharp on one edge but ragged on the other. This is easier to avoid on a pad or a cushion of paper than on a hard, unyielding surface.

Once your work sheet is positioned, lay a slip sheet (another sheet of bond paper is fine) over the lower area where the heel of your hand will rest. This will protect the writing surface from moisture or oils from your skin.

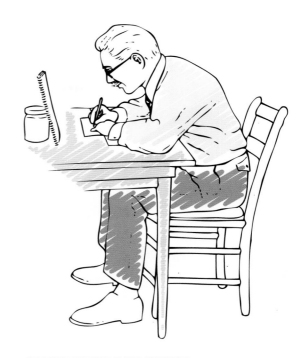

The top edge of the slip sheet should be well below the "descenders" of the writing (the tails of the letters p or y, for instance). Two inches below is good. Although you should never use the top edge of the slip sheet as a guide to the straightness of your writing line, you will be aware that it's there. And because you can see it, it may interfere with your perception of the horizontal and thus with the straightness of your writing. So prevent this difficulty before it arises by keeping the edges of the slip sheet square with the edges of the writing paper.

CORRECT POSITION FOR WRITING: Both arms and elbows are supported by the table or desk, and both feet are flat on the floor. The head should be as close over the surface as possible, and both hands should be closely involved with the work.

When you write, you'll move the slip sheet down each time you begin a new line, so that it doesn't interfere with the descenders of the letters on that line.

Prop this illustration book up above your writing area, as shown in the illustration. This way it will be close enough for easy reference but it won't interfere with you or your writing area.

As you write, your head should be over the work and your face as close to it as your vision will permit. This position gives you complete control over what you're doing. (Obviously, you cannot control your work unless you can see it properly.) Now your whole attitude is no longer of a mere recorder of words, but of an artist as minutely concerned with detail as an engraver or watchmaker.

THE LEFT-HANDED CALLIGRAPHER

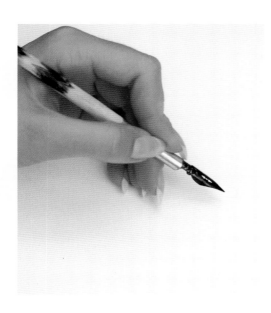

The left-handed writer needs to make some modifications in the method employed by the right-handed calligrapher. This is accomplished by altering either the type of pen nib used or the position of the writing hand.

Some suppliers make left-handed nibs angled so that the nib is shorter on the left side than on the right. These are called left-oblique nibs. Also available are nibs that are both oblique and bent into a curve. These are known as left-hand acute-oblique nibs. An oblique nib used in the left hand automatically meets the paper at the correct angle of 45° when the paper is slanted slightly to the right. Nibs with the straight chisel edge used by right-handed scribes can be modified for left-handed use. Such modifications, however, should be done professionally because it's very easy for an inexperienced person to destroy the nib.

Be kind to yourself. Calligraphy is an art to enjoy. If you get tired, distracted, or impatient, take a break—come back when you're rested and ready to concentrate.

Respect The Rule Of Letters. It will save you much useless repetition so that each time you make a letter it can be an improvement over the last one.

The list of manufacturers in the previous chapter on the scribe's equipment indicates some companies that make left-oblique and acute-oblique nibs.

The left-handed writer using a straight chisel-edge nib can achieve the correct 45° pen angle in two ways. The first is to angle the paper to the right almost to a 90° angle. The writing must then be done top to bottom, as illustrated, on guidelines that appear vertical or nearly vertical from the scribe's point of view. This is a perfectly satisfactory technique. The alternative is less satisfactory and involves hooking the writing hand over the writing line from above. This presents the constant possibility of smudging or smearing the characters that have just been written.

All beginning calligraphers are advised to disassociate their everyday hand from their new broad-pen art; this is particularly important for the left-handed writer.

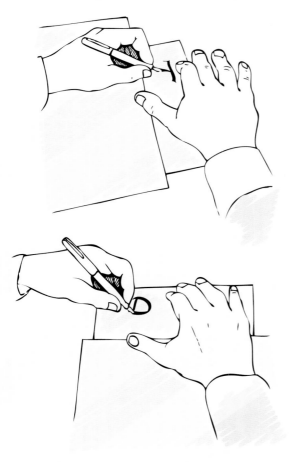

The left-handed scribe's mode of writing with a square-ended, or "straight" nib. The line of writing must be from top to bottom, with the paper slanted accordingly.

The left-handed scribe's "overhand" mode of writing with a standard, square-ended nib. The angle of the paper may be altered to suit the writer's individual preference.

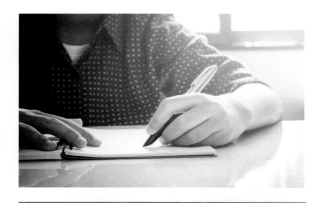

See also page 25 for a note on left-handed writing. Left-handed scribes use a left-oblique nib and reverse the hand position used by right-handed people.

If you're left-handed, you can work perfectly satisfactorily with this book as soon as you have decided on the technique suited to your own needs.

Left-handed calligraphers are in good company, by the way. Leonardo da Vinci, who was a southpaw, wrote the Italic hand and faced all the problems of modern left-handed scribes confronted by an art evolved in a world dominated by the right-handed. Today, however, you won't need to go to the extremes to which da Vinci resorted. He wrote left-handed and backward. He wrote quite well, but forced the reader to hold the writing in front of a mirror in order to be able to read it. (Some say this was his way of keeping some of his more controversial notes from being read by those who would have been hostile to his advanced ideas. Perhaps he figured that people who didn't care for his theories lacked the imagination to think of the mirror gimmick.)

Now that you know something about the scribe's physical equipment and environment (and the attitude you should take toward your calligraphy), you can move on to the actual process of making the letters. The following chapters thoroughly explain how to write in the classic Italic style. All the strokes, forms, and proportions are illustrated in minute detail. All you need to know in order to draw a basic alphabet is clearly and carefully detailed. How well you succeed depends on how well you follow directions. Take your time. Remember that quality is what matters, quantity is not an issue. Recognize that all the rules and cautions are important and are there to help you. Understand, too, that you must be your own teacher—even if this book makes you want to continue and take calligraphy classes. All that even the best teacher can do is show you how and give you examples—it will always be you who must make your hand perform.

THE PEN AND HOW TO USE IT

It's not at all unusual to have some difficulty getting the ink to flow when you're beginning to work with a broad pen. The cause could be unfamiliarity, inexperience, or a faulty pen. These pens are usually inexpensive and not always perfect, so they may require some adjustment or breaking in. The series of rules and actions listed below will correct almost any failure of the pen to start properly. These eight troubleshooting tips should be used, in order, until the problem is solved. The first three apply any time; the other five are not often needed.

Scratching to start—paper ruined.

Pressing and rolling several times at same spot. No marks visible. The cross of the T covers the mark.

1. Be sure your pen is fully assembled and the nib securely seated in the pen.

2. Check that the pen is *properly* loaded. Follow the instructions that accompany it.

3. Press the nib to the paper without moving the nib; press down and lift it up again. If the edge has left an ink mark along its full width, place the nib back on the still-moist mark and begin to write. There will be no ugly blots or scratches to mar the paper.

4. If you try step 3 and no ink appears on the paper, place the pen nib back where it was before and—with out any sideways movement—twist the pen slightly, rotating it along the long axis of the barrel. This causes the two parts of the nib to rub against each other. (This is to break up any dry or gummy ink in the cleft of the nib and to encourage the liquid ink to descend to the writing surface.) Lift the nib again to see if the ink has reached the paper. If so, place the pen back on the same spot and proceed to write as before. If not, try step 5.

5. Hold the pen so that it won't splatter you or the writing surface, then compress the reservoir (as you do when you load the pen) or the cartridge and expel a drop of ink on a piece of scrap paper. Lay the *back* of the nib in the ink drop, and thoroughly wet the whole end of the nib. Then repeat step 3.

6. Still no luck? Moisten a piece of paper with your tongue, and lay the nib against the moist area. The saliva will emulsify any oily film from the manufacturing process that may be repelling the water-based ink. Repeat step 3.

7. If you still have no success, hold the nib up to the light. If light shows through a gap between the two parts of your nib, you have a problem. Sometimes you can solve it by bending the two parts of the nib down and together. However, you may prefer to proceed to step 8.

8. Return the pen to the supplier.

Don't ever persist in trying to work with a pen that's not functioning efficiently. You won't produce good work; you'll get extremely frustrated; and you'll certainly ruin your paper.

THE CORRECT WAY TO HOLD THE PEN

In broad-pen writing, the pen is held by the thumb and the first two fingers. The tips of all three should meet at about the same distance from the end of the pen barrel, and at about the same distance from each other; in this way the thumb and fingers form a triangular grip for the pen. All five fingers are curved convexly (inward), not bent backward; the barrel of the pen should be at an angle of about 45° to the writing surface. The last two fingers are curled under the palm; they support the weight of the hand and serve as skids when the hand moves over the paper. The fingers control the pen. The heel of the hand remains nearly stationary while the letters are formed, moving in "hitches" after every two or three letters. Forget about free-armed, round-hand circles; they have no place in the Italic hand.

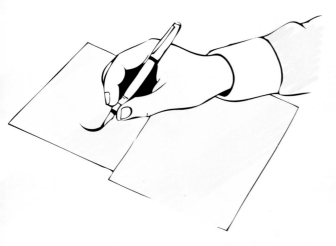

Correct position of the pen hand in writing. The ends only of the thumb and first two fingers grip the pen lightly, as low on the pen barrel as is comfortable. All fingers are flexed convexly, and the last two fingers are curled below the palm so that the nails act as skids on the writing surface. The slip sheet is under the heel of the hand.

THE 45° ANGLE

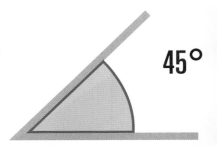

When you're ready to write (unless you are left-handed, in which case refer to the specific techniques for left-handers discussed in the chapter on the scribe's environment), the position of the chisel edge of the pen nib must be adjusted so that the edge of the pen is angled at 45° to the edge of the writing paper.

You actually have *two* 45° angles to bear in mind. One is the angle of the nib's edge to the writing surface. The other is the angle of the pen barrel in relation to the horizontal—in this case the tabletop. Both angles are approximate and differ slightly between scribes and among variations in style by the same scribe at different times. There should, however, be no alteration in either angle during any piece of writing that is intended to be uniform in appearance.

One caution: the angle of the nib, if not exactly at 45°, should (for these letters) be a little steeper but never flatter. A steeper angle imparts greater weight to the horizontals and less to the verticals; this permits (and encourages) a more condensed pattern, which may be helpful to you in your early attempts because the tendency is usually to write in a too-extended style. This book encourages you to keep your writing tight; it's always easy to relax and open up the writing later, if you wish, but it takes effort to close up an open hand. The pen angle is absolutely critical. If it's wrong, you are doomed to failure no matter how hard you try, so get it right before you get further involved.

You never need to make awkward adjustments of the pen angle by twisting the wrist or using an unnatural grip on the pen; just hold the pen comfortably and proceed to write in the most natural direction.

If your line of writing goes uphill or downhill on the paper, simply adjust the paper. Rotate it clockwise or counterclockwise until your lines of writing come out parallel with the top edge of the paper.

UNDERSTANDING PEN STROKES

In order to understand just how the movement of the pen produces strokes of different widths, study this drawing of the pen and the strokes that result from moving it in certain directions.

The thinnest possible line is made by moving the pen along the 45° line from lower left to upper right, or from upper right to lower left. This we shall call the "ice-skate mode"—there is more than one reason for this name.

The thickest possible line you can make with the same pen results from movement at a right angle to the thinnest line, also in either direction. We shall call this the "squeegee mode" because, like a squeegee, the chisel edge makes its pass across its full width. Note the square ends to the squeegee stroke.

THE STAR

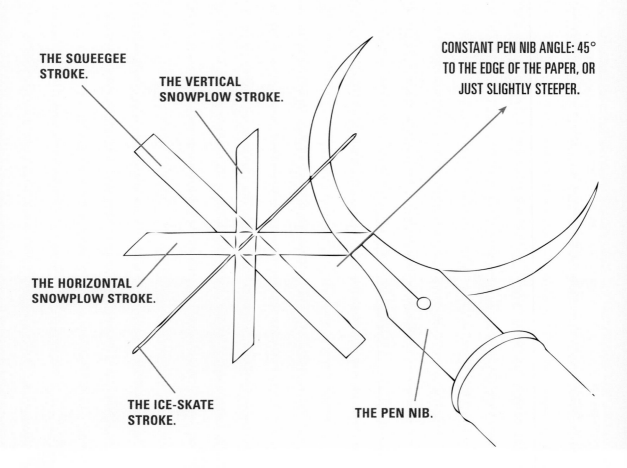

THE SQUEEGEE STROKE.

THE VERTICAL SNOWPLOW STROKE.

CONSTANT PEN NIB ANGLE: 45° TO THE EDGE OF THE PAPER, OR JUST SLIGHTLY STEEPER.

THE HORIZONTAL SNOWPLOW STROKE.

THE ICE-SKATE STROKE.

THE PEN NIB.

If the pen is moved horizontally (without changing the 45° angle of the nib), it makes a line that's broader than the ice-skate stroke but narrower than the squeegee stroke. We'll call this the "snowplow mode" because of the angled movement of the chisel edge as it "shaves" along in the manner of a snowplow blade. Vertical movement produces a line similar in weight and character to the last. This is a "snowplow" stroke also.

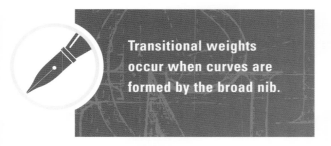

Transitional weights occur when curves are formed by the broad nib.

Note that although each snowplow stroke is obliquely cut off (slanted) at each end while the squeegee stroke is square at each end, the beginnings and ends of these and all strokes are at the constant 45° angle to the page.

By combining all four strokes, you can make an eight-pointed star—a good test for a beginner's understanding of the three odes just described. Remember, the pen is never rotated. The 45° angle is correct for all strokes.

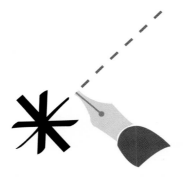

CONSTANT 45° ANGLE.
MAKE THE STAR LIKE THIS.

All the straight or nearly straight strokes you'll make in the Italic alphabet conform to those included in the star. Curved lines change in thickness as the nib changes direction. Remember—the *angle* of the nib's chisel edge does *not* change.

If short segments of straight lines are drawn consecutively to form an eight-sided figure, or octagon, the result is a pair of angular facing and connected crescent shapes, as shown here. If another, similar figure is made with all the pointed facets rounded off, the result is a graceful thick and thin shape suggesting an "O." Here is a step-by-step illustration of the pen movements involved. As always, the pen nib is held at 45° throughout.

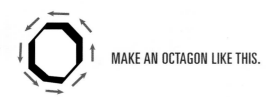

MAKE AN OCTAGON LIKE THIS.

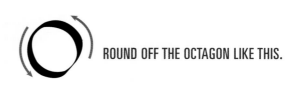

ROUND OFF THE OCTAGON LIKE THIS.

The pen movement described earlier as the squeegee mode is used to make "pulled" strokes. Examples of pulled strokes are found where the pen is moving from upper left to lower right, or from lower right to upper left. (To be strictly accurate, some of these strokes should be described as "pushed" strokes, but for the sake of convenience and simplicity they will all be referred to as "pulled" strokes.) Pulled strokes should be stressed and strong; sometimes they are elongated a little or even slightly straightened.

In very formal work, all strokes are from top to bottom and from left to right. In this case a small o or a capital O, for instance, is made in two strokes; each stroke moves from upper left to lower right of the character, as shown here. When you try to duplicate these characters you will understand why "pushed" and "pulled" are good descriptive terms for these strokes.

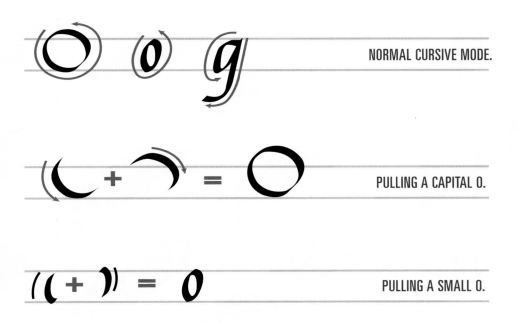

NORMAL CURSIVE MODE.

PULLING A CAPITAL O.

PULLING A SMALL O.

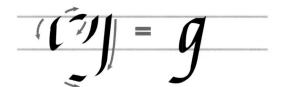

PULLING A SMALL G. FIVE PARTS ARE ALL MADE SEPARATELY.

When you make a pushed stroke you are, literally, pushing the pen nib against its natural inclination, and you may find that the pen nib tends to chatter, catch on the paper, or sputter. This is most likely to occur when the pen is moving in the squeegee mode from lower right to upper left. You may also find here that your pen or your hand obscures part of the unfinished letter, making it difficult to add a finishing stroke. The solution to both these problems may be to change the direction in which the stroke is made and to pull all diagonal strokes from top to bottom and from left to right, as suggested for large or formal work. You'll also find this technique helpful when you're working with a particularly sharp nib or on a textured or soft surface.

The ice-skate mode of nib movement can also present some problems. Like an ice skate on the ice, the nib tends to continue in a straight line along its edge unless it's very specifically guided into a curve. This is due to two factors that tend to interfere with your control of the nib. One is the natural tendency of the nib edge to move like a skate; the other is the ease with which the hand moves from upper right to lower left, or vice versa. Strokes that are made from upper left to lower right, or vice versa, are more difficult to manage and it takes care and experience to blend these strokes into and out of graceful curves.

You'll find it harder to control the ice-skate strokes if you try to write rapidly. Go slowly and pay close attention when your nib is making the kinds of transitions shown in the diagrams. When making the transition from any direction into or out of an ice-skate stroke it's more important than at any other time to maintain a very light pressure on the nib to avoid losing control to the ice-skate effect.

The thinnest strokes, especially when they form diagonal joins between letters (joins will be discussed more fully later), should be hairline-fine, sometimes to the point where they disappear altogether. It's easy enough to make thick lines thick but the thins are critical and may not show adequate contrast with the thicks, especially when you're using smaller size nibs. If you're patient you can experiment with a steel nib and use a fine Arkansas oilstone (available from hardware or art supply stores) to sharpen the nib so that it will produce sharper thins. You must tread a fine line between a too-blunt edge on the nib and a razor-sharp edge that will snag or actually cut the paper. It's worth making the experiment, however, and the worst you can do is destroy a cheap nib that can be easily replaced.

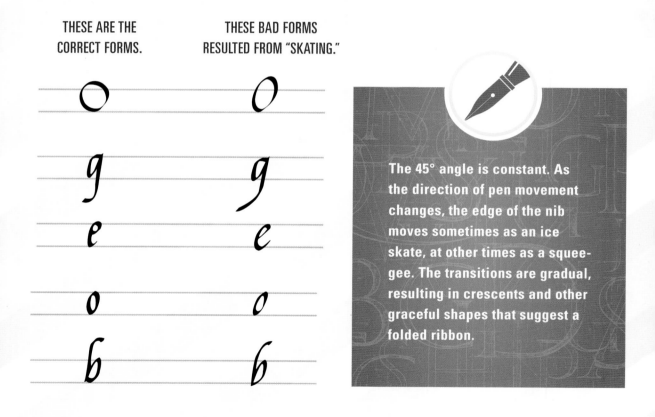

THESE ARE THE CORRECT FORMS.

THESE BAD FORMS RESULTED FROM "SKATING."

The 45° angle is constant. As the direction of pen movement changes, the edge of the nib moves sometimes as an ice skate, at other times as a squee-gee. The transitions are gradual, resulting in crescents and other graceful shapes that suggest a folded ribbon.

HOW THE LETTERS ARE MADE

Now that you have some understanding of how the broad pen is used to draw strokes of different weight—different degrees of thickness and thinness—you can move to studying the characteristics of the letters of the Italic alphabet that you can make with these strokes.

THESE PICKETS ARE SLANTED AT ABOUT 7° AND ARE ABOUT 1½ PEN WIDTHS APART.

THIS IS WHAT A 7° ANGLE LOOKS LIKE. DON'T EXCEED 8°!

The characteristic pattern of Italic writing suggests a picket fence, like this / / / / / / / / / / . Rhythmically made, downward strokes form the pickets, which have a forward slant of about 5° (but not more than 8°). Essentially, these pickets are contained between horizontal lines, the baseline and the waistline. Occasional strokes jutting out above and below (ascenders and descenders), and certain curves, diagonal strokes, and loops here or there, all produce legible characters and give the hand artistic interest. But the regularity of the picket pattern dominates throughout.

There are, of course, exceptions to every rule, and a few letters seem to be totally incapable of conforming to this pattern because they contain no straight vertical lines. These letters are o, s, v, w, x, and z. When you study the proper construction of these letters, you'll see how ingeniously the problems have been dealt with.

The first technique you'll learn in this book is how to construct the picket fence. And, when you start to form letters out of the pickets, you'll see how they depart from straightness only enough to form legible characters without sharp angles at the points of thinness where horizontal and vertical strokes flow into each other. You'll discover, in fact, that characters that *look* "curvy" or rounded are still controlled by the picket fence pattern. Sharp angles, however, *are* required in many situations, such as where horizontals and verticals cross or meet from two different directions—as in the cross of a t or the top right corners of a and g. These shapes are made in a specific manner that must become habitual.

The ascenders and descenders form another, less regular, pattern on the picket fence base. They extend above or below the picket fence at random locations, depending on the letter being written. The uniformity of all these basic elements in shape, weight, and height is very important in giving the overall work an image of order and harmony.

The rhythm of writing Italic is up, DOWN, up, DOWN. The pen is moved up and down largely by movement of the fingers, hand, and arm combined, while horizontal strokes are managed mostly by finger movement. Except for quite large writing, the arm and hand do not slide on the paper. The secret lies in flexible movement of the hand's bones and muscles under the skin. Except, again, for very large lettering, avoid wide, loose movements of the whole arm.

The Italic technique makes use of the natural tendency to make the downward strokes firmly, with a little more vigor and pressure than you use to make the upward strokes. The upward strokes are so light that they may almost disappear. Use only enough pressure to transfer the ink properly to the paper. The pickets, which are nearly upright (vertical), are made on the DOWN strokes. The up strokes are angled toward the right, and therefore thinner.

The making of pickets has two fundamental modes. One produces "arcades," as seen in the arches of m and n and in modified form in such letters as b and p. The other mode produces "scoops," best exemplified by the letter u but also figuring very importantly in letters such as a and g.

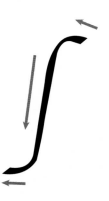

THIS IS THE WAY HORIZONTALS AND VERTICALS FLOW INTO ONE ANOTHER. THERE IS NO WAVINESS IN THE THREE STRAIGHT SEGMENTS.

As a student of the Italic hand, one of the most important things for you to remember is the significance of this picket fence—this row of parallel vertical strokes. And when you study the picket fence you'll realize that the Italic letters you are making are brand new geometric figures that bear little relation to the letter shapes you take for granted.

SHOWN HERE ARE THE NUMBER AND DIRECTION OF STROKES USED TO MAKE THE ITALIC MINUSCULES.

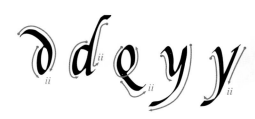

a b c d e f g h i j k l

m n o p q r s t u v w x y z

Here are two examples of decorative ornaments that match this style.

The last five are alternative forms to try later, after you have mastered the simple forms of the alphabet drawn here.

d d e y y

These models are oversize to show detail. They were made with a Sheaffer Italic B nib. Each letter is begun at the purple dot. Don't lift your pen between strokes for any of these letters except for the crossing of f and t, the dotting of the i and j, and for p and x. (The alternative letters in the bottom line, however, are all made with pen lifts except for the first y.) Note that each arrow indicating a second stroke within a letter is keyed with a small Roman numeral ii. Study these characters carefully, and look for the smallest clues to understanding each part of each letter. For instance, you should have noticed the similarity between the first d and the q in the bottom line.

The slant of your writing, i.e., of the picket pattern, must be considered when you look at the weight of vertical strokes in relation to the weight of horizontal strokes. Other conditions being equal, the more you slant your letters, the thinner the verticals will be and the heavier the horizontals. If you want a stronger slant without changing the weight of verticals and horizontals you can flatten the nib angle a bit. This is a very limited device, though, and too much slant will ruin the whole pattern. The best slant is just enough to be obvious, and all the examples in this book should give you a feel for the correct effect.

An o, for instance, is a circle. Right? Wrong. You must now visualize the o as part of the picket fence—not as a circle but as two vertical, parallel pickets, properly spaced and slanted and joined at the top and bottom. As you begin to learn the Italic alphabet, all the letters must be reconsidered in an entirely new light. Your problems as a beginning calligrapher are more likely to result from this unfamiliarity than from any difficulty in actually making the strokes.

alphabetically (in pickets)

alphabetically (in italic script)

A comparison of rigid pickets with their modified forms, which constitute legible characters. The picket pattern should be visualized when you are writing, and the strokes made to conform to it. Make all your pickets touch the guidelines at top and bottom, or even overlap them slightly.

In order to make the pickets into parts of letters they must be connected, elongated, shortened, angled, or otherwise modified. The first modification that you will study appears, in some form, in every minuscule character except f, j, s, and z. Because of its shape we'll give it the convenient name of bird's head for future reference. This shape is so birdlike that, by drawing a body for it, we can create a realistic design like this. We can call this creature a Calligraphy Bird.

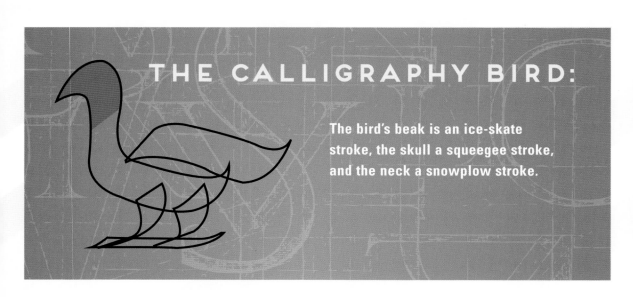

THE CALLIGRAPHY BIRD:

The bird's beak is an ice-skate stroke, the skull a squeegee stroke, and the neck a snowplow stroke.

Now, prepare to take your first step toward mastering the Italic alphabet by drawing the picket fence. First, examine the row of pickets shown here. Compare their breadth (the picket is a snowplow stroke) with their height and with the distances that separate them from each other. The slant of the pickets is only about 5°, but it must be consistent. As you develop your own style of Italic writing you may find that your angle is not precisely 5°, but slightly more upright or slanted. This is quite acceptable as long as the slant is noticeable (it is, after all, a primary characteristic of the Italic hand) and consistent. This consistency of slant is indispensable to Italic calligraphy.

THE "PICKET FENCE."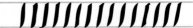

Note that in this book we assume this slant without constantly mentioning it, and the strokes referred to as "verticals" are understood to be these slightly slanted, upright pickets. (Since all horizontals are at right angles to these verticals, they have a slight slant downward to the right. This slant will also be assumed.)

- Simple mechanical pickets.
- The same pickets made cursively, that is, joined in zigzag fashion without lifting the pen.
- The zigzag modified into an arcade.
- The zigzag modified into scoops.

You must be able to make a reasonably accurate version of this first row of pickets before you proceed to the next step. Watch the proportion of pen width to height and to the spaces between pickets. Try for mechanical regularity.

PICKETS IN A CONTINUOUS ZIGZAG PATTERN.

Now, make another row of pickets of the same shape and proportions as the preceding row, but with this one difference: This time, do not lift the pen between pickets. Your effort should produce a *zigzag*, as in the second illustration. Don't allow the connections to have any effect upon the pickets or the spaces between. Work on this pattern until yours is a good reproduction of the model.

The next illustration shows a line of pickets made almost exactly like the last, except that now the diagonals are arched. Notice that the connecting diagonals start out steeper than before, and curve into each succeeding picket with a blunt, thick, *almost* pointed bird's head. So the bird's head must be mastered before continuing.

THE ARCADE PICKET PATTERN.

mmmmmmm

mnhbpkr

THE ARCADE FAMILY OF LETTERS.

The same principles apply here as for the pen strokes described earlier. It is the direction of movement that governs the thickness of the lines. The beak is an ice-skate stroke, the skull (the thickest part) is a squeegee stroke, and the neck is a snowplow stroke. Study the diagram and practice the bird's head until you have some measure of control over it, then make your third line of pickets connected by birds' heads. This pattern must also be practiced until you can do it well, and it must be understood and mastered before you can correctly make Italic letters such as m, n, h, b, p, k, or r—the "arcade" letters and their close relatives.

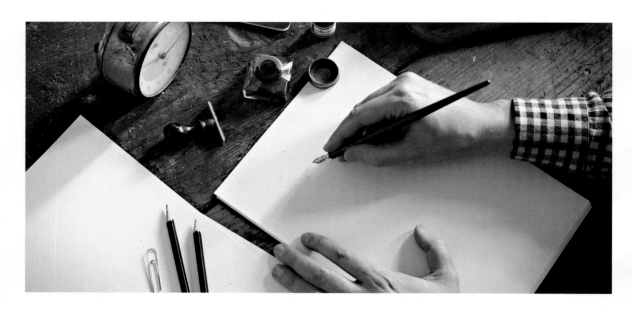

THE **SCOOPED** PICKET PATTERN.

THE SCOOP FAMILY OF LETTERS, AND THE SCOOP USED TO JOIN LETTERS IN A WORD.

adgquy·alley

The scoop pattern of connected pickets is very similar and is made by joining the same pattern of pickets with a blunt, sharply curving bottom scoop that tends to straighten as it ascends to the top of each succeeding picket before reversing to descend as a straight line. It should have occurred to you that the pattern is an accurate replica of the last one when viewed upside down. (You may invert the page to test the truth of this.) Mastery of the scoop pattern is required for making the correct Italic versions of a, d, g, q, u, or y. Most joins or connecting strokes between letters (which you'll study later in this book) are also scoops. The scoop pattern must also be mastered before proceeding. Don't allow the pickets to become separated any more than those in the model.

You will more readily understand the forms of the Italic characters if you look first at their "skeletons." The skeleton of a letter is an imaginary line that represents the track traced by the center of the pen's chisel nib as the character is written. By tracing over the correct skeleton of a letter with a broad pen held at the proper angle, a line of varying weight is produced automatically and without any manipulation of the pen. The "folded ribbon" effect thus produced is a primary characteristic of Italic and other broad-pen alphabets. The skeleton of any given thick-thin letter may be determined by drawing a line through the center of each stroke. Examine the diagrams in the margin to see how understanding the skeleton of a letter can help you control the shape of the character as you make it.

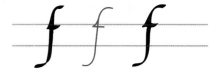

The skeleton of the letter f shown between two examples of the letter. **NOTE** how the broad-pen examples conform to the skeleton.

The stem of the f enlarged, showing the skeleton as a white line traced by the split in the pen nib. The continuous line on the left is made by the left half of the nib. The other parts represent the track of the right half of the nib.

As mentioned earlier, all the letters of the Italic minuscule alphabet are basically constructed from a small number of strokes or combinations of these strokes. Within the diagrams on these pages you can see nearly all the strokes and details that can be assembled in different ways to form the minuscule alphabet described in the following pages. Examine the superimposed images and you will see pickets, scoops, arches, stems, horizontals, birds' heads, flags, joins, and pen reversals.

These diagrams show the details that start, finish, curve, connect, and otherwise modify pickets to form legible characters. Note that most strokes are basically straight, even if they're only one pen width in length. This is a very useful thought, not often understood by otherwise skilled scribes. Being aware of the principle and at least trying to maintain this brief straightness of line is a good safeguard against malformed flags.

Pay careful attention to the bird's head. When you come to imitate the shape with your pen, compare your bird's head to the models and repeat your effort until you can make this shape correctly every time. Be especially aware of where the shape curves and where it is straight. Look back at the letter skeletons to see how your nib moves. The variations in thickness are automatically imparted by the broad nib.

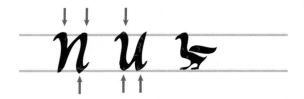

THE CALLIGRAPHY BIRD. This creature is found all through the Italic minuscule alphabet. Observe how the n and the u each contain three birds' heads, which are theoretically identical even though one is inverted.

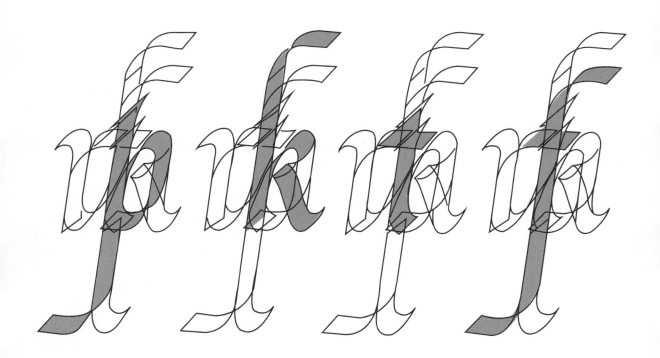

Here is a very useful illustration of the way all the components of the Italic minuscule alphabet are interrelated. Study this design for a while; familiarize yourself with the names given to different features, and trace out the shapes with your eye. Then, without reading the call-outs that surround the diagram, see how many letters you can make out and note how exactly they share so many features. Next, study the call-outs and the details they describe and try to fix what you see in your memory. Later, after you have worked on the whole alphabet, come back to this page and study the diagram again. You should learn even more from it after you've had some practice at making the strokes it illustrates.

Study also the transitions between horizontal and vertical strokes (as in making flags), and the arches and scoops. Again, you should practice these shapes until you can make them correctly. The way the pickets and curves overlap and diverge must be done exactly right.

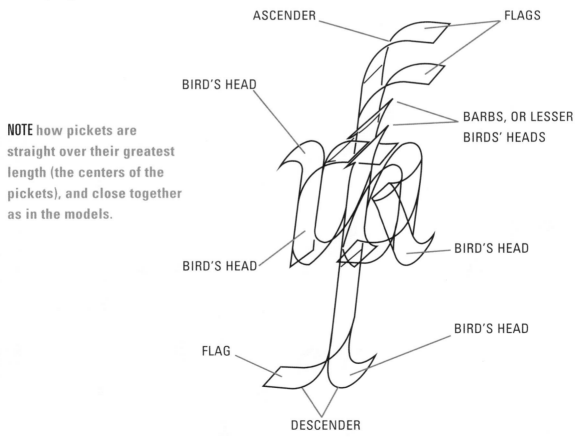

ASCENDER

FLAGS

BIRD'S HEAD

BARBS, OR LESSER BIRDS' HEADS

NOTE how pickets are straight over their greatest length (the centers of the pickets), and close together as in the models.

BIRD'S HEAD

BIRD'S HEAD

BIRD'S HEAD

FLAG

DESCENDER

Correct spacing is a critical factor in Italic writing, and spacing falls into four categories: space within letters, space between letters, space between words, and space between lines of writing. Here, with explanatory illustrations, are the underlying rules in each category.

Vertical strokes within individual letters are separated by a space approximately $1\frac{1}{2}$ times the width of the strokes themselves. This is as tightly condensed as Italic ought to be written. A little more space is almost certain to creep in, and that's all right as long as the space doesn't exceed the width of two pickets.

Letterspace—the established term for the space between letters—is comparable to the spacing of individual strokes within letters. Each letter in a word should appear to be the same distance from letters on either side of it. The extra weight where letters are too close or "airy" spots where the spacing is too open are both serious flaws, no matter how perfectly formed the letters themselves may be. The space within and between letters is judged by eye, on the basis of area or "air" rather than on actual distance. Generally, curves are allowed to be closer than straight lines since they curve away from one another. Parallel straight lines should be given a little more air. As you become more proficient in calligraphy you will find that your eye makes these judgments almost automatically. You will literally see if your spacing is correct.

COMPENSATING FOR A "HOLE."

Compensating for a "hole."

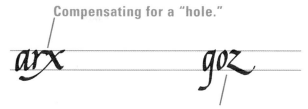

Closing up letters without joins.

Wordspace—the space between words—needs to be only enough to announce the division of one word from the next. This is usually stated to be less than the width of an n. Beginners often tend to leave more space than necessary between words, but any space beyond the required minimum leaves a visual "hole." This makes the writing more difficult to read and causes an unnecessary interruption in the regular gray line of writing, which should consist of an even proportion of black shapes and white background.

	ASCENDER LINE
Royal	WAISTLINE
	BASELINE
	DESCENDER-ASCENDER LINE
	W
lag	B
	D–A
	W
lab	B
	D–A
	W
alley	B
	D

THE RULES ARE EQUIDISTANT AND
4.5 PEN WIDTHS APART.

The distance between lines of writing, as well as the height of the letters, is governed by a series of parallel horizontal lines: the baseline, the waistline, and the ascender and descender lines. For standard Italic writing, the distance between each of these lines should be about $4\frac{1}{2}$ or 5 times the width of the broadest line that you can make with your pen (or whatever writing instrument you're using).

Equal linear spacing—the verticals look tight.

EACH LETTER SHOULD APPEAR TO
FLOAT HALFWAY BETWEEN THOSE
ON EITHER SIDE OF IT.

Equal optical spacing—the letters
appear to be comfortable together.

The minuscules, or small letters, are written between the baseline, which is your writing line, and the waistline. The bodies of the characters should be large enough to overlap these lines by a little bit. Above and below these two guidelines are the ascender and descender lines. The ascenders of the letters should not quite reach the ascender line, and the descenders should stop just short of the descender line. The descender line also serves as the ascender line for the line of writing below. As ascenders and descenders stop just short of the corresponding guidelines, there is no contact or tangling of parts of letters from adjacent rows of writing. (When you begin the majuscules, or capital letters, you will see that they are lower than the ascenders of the minuscules and end below the ascender line.)

These rules of spacing are based on classical tradition, but standardized and simplified for the student. They are safe and simple and should answer all the questions that a beginning calligrapher may ask. But remember that however expert they are, no two calligraphers—ancient or modern—will be satisfied with only one set of rules. As you become more skilled in calligraphy you will require and discover new styles and techniques of spacing to match your developing skills. For the time being, however, be content with the basic rules; they will serve you well.

For your practice with this book you should use the same nib that was used in making the examples in the margins. The pen used was a Platignum fitted with a Broad nib, which is midway in breadth among the seven nib widths available for this pen. The breadth of the chisel edge of this nib is about 1.3 mm, somewhat less than $\frac{1}{16}$ inch. This is large enough to reveal details of the letter forms clearly, but not too large to use with hand movements similar to those employed in the everyday Italic longhand you may be using later.

THREE DEGREES OF DENSITY OF THE PICKET PATTERN:

Proportionally —the writing is too condensed, making it difficult to maintain even-looking letter spacing.

Proportionally —the pattern is fairly dense, but there is comfortable space between letters. This is the style recommended in this book.

Proportionally —this is about as far apart as joined letters can be. Note that some letters that are not joined here would have joined naturally if the pickets were closer.

The height of the Italic small letters should be about $4\frac{1}{2}$ to 5 pen widths. Multiply 1.3 mm (the breadth of the nib) by 4.5 and you get 5.85 mm. Thus you see that 5 or 6 mm is an acceptable approximate size for your efforts here. The guidelines shown in this book are 5.5 mm apart. If your particular pen seems to make a slightly wider or narrower broad stroke, you can easily compensate by writing your letters slightly larger so that they overlap the lines, or smaller so that they fall within the lines. However, you should be using a nib as close to 1.3 mm as possible.

With the exception of some special examples, the letters drawn in this book conform to these proportions.

If you want to reproduce these models with another size pen nib, choose one that is larger, not smaller, and adjust the height and spacing of your letters to keep the work in proportion. To do this you can either use one of the detachable sheets from this book, or make a new set of guidelines spaced 4 to 5 times the width of the nib you plan to use. To determine the correct space between the guidelines, turn your pen sideways and make a column of "checkers," as shown.

LETTERSPACING AND WORDSPACING MUST BE MINIMIZED AND CONSISTENT.

A	
W	
B	*flag jolly pad*
D-A	
W	
B	*shag glory log*
D	

Adjacent lines of writing share a descender-ascender line. To avoid getting tangled up with each other, ascenders and descenders must not cross this shared line.

Within the limits of 4 and 5 pen widths, you can experiment and exercise your own preferences. Remember that the low letters of the Italic alphabet (a, c, e, i, m, n, o, r, s, u, v, w, x, z), and the bodies of most letters with ascenders and descenders, should just barely overlap the baselines and waistlines.

To make guidelines you can rule very faint lines on your writing paper, and erase them when the piece is complete and the ink is thoroughly dry. If you're using a thick or heavy paper, this is the best system.

Alternatively, you can use a ruled sheet that slips underneath your writing paper, so that the rules show through very faintly. In this case the guide sheet must be positioned securely so that it can't move while you're working. At the end of this book you'll find guide sheets for use with nibs of different sizes. These sheets will work well under many types of bond paper.

When you progress to the point where you want to experiment with other alphabets, you will find that you sometimes need differently proportioned guidelines. Gothic minuscules, for example, require about 5 pen widths between the baselines and waist-lines as do Italic minuscules, but the ascenders and descenders on Gothic characters only extend $2\frac{1}{2}$ nib widths; therefore the ascender and descender lines must be adjusted.

Once you have learned to make the correct forms and have developed the necessary hand control, you will also be pleased to discover how easy it is to express this skill through arm control. It's a small step from completing the exercises in this book with a small nib to making six-inch-high letters with a piece of flat chalk on a blackboard. This will prove to you that it's your mind, not just your hand, that you've trained to control the making of the letters, and it will explain why this book emphasizes the importance of thinking about and examining the letters instead of just rushing ahead to get them on paper.

In any calligraphic alphabet it's important to consider not only the strokes, but the holes and other open spaces between them. These spaces, called counters, must be properly shaped and proportioned. The most obvious counter is the hole inside the o. Especially important in the Italic minuscule alphabet is the counter of the r, which leaves a large void in the lower right quadrant of that letter. Sometimes the next letter can be modified to absorb some of that space, as the illustration shows. Usually the only remedy is to make that next letter very close to or in contact with the r.

Note also the characteristic shapes of the bowls of the closed letters such as a, b, d, g, p, and q. They should be correctly shaped and uniform.

ghkmopsvwxyz

Selected minuscules, showing counters in purple. All "bowls," as in g and p, form counters. Some letters, such as k, m, and z, have 2 counters. Others have 3, like w, or even 4, as does x.

abdgpq UNIFORM COUNTERS.

ek ʃ

NOT TOO OPEN. THE TOP COUNTER IS SMALLER.

rorra wri ru rx rk

CLOSE UP LETTERS THAT FOLLOW THE R.

The Golden Hind

The counters of majuscule or capital letters require even more careful attention, and will be discussed later when you're introduced to the Roman majuscule alphabet.

THE ITALIC MINUSCULE ALPHABET

The Italic hand, which you will learn by studying the following pages, is derived from the classical Roman alphabet and has changed very little over the past 500 years. In fact, considering the passage of half a millennium and the crossing of the language barrier, the differences are surprisingly small.

You will begin with small letters (minuscules) in their simplest and easiest versions. These 26 characters can all be made using only a few basic strokes with certain minor variations.

Your approach to the Italic alphabet will not be organized alphabetically but according to geometric similarities. The Italic minuscules can be divided into "families" of characters that have a lot in common. For instance, the n, m, h, k, b, p, and d are all related. At first the m and d may appear to be quite different, but as soon as you start tracing the progression in this series you will see the similarities and understand how mastering one letter leads naturally to mastering the next.

All of the 26 letters of the Italic alphabet can be sequenced in this way, and each one will reveal a clear relationship to its neighbors.

After you've developed a correct and regular pattern to these basic, conservative letters you may start to study the more demanding, sensitive variations presented later on in the book.

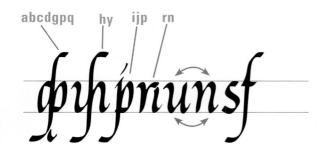

Study these figures to see how the minuscules share many basic strokes.

NOTE that s and f begin and end with similar flaglike strokes.

OSVWXZ

The groundwork, though, is very important. The more you develop the regularity and correctness of each simple letter, the more rewarding will be your experimentation later on. And the less likely you will be to fall victim to ambition and be tempted to exceed your skill at this level.

This is an important point, because the urge to be too free and to overdo irregular and flourished forms is a temptation that the beginner has to guard against all the time. If you haven't grasped the simplest form of a letter, you're not going to be able to control a demanding variation of it.

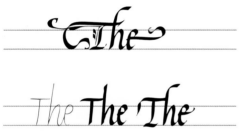

Flourishing demands great control and discipline. The apparently wildly active embellishments of the top example are quite firmly anchored to the very carefully and faithfully constructed basic letter forms. The line example shows the correct skeletal shapes and underlies all three of the broad-pen versions shown above. Don't think of "fancy writing"; think of correct writing with well-constructed ornaments.

As an example, study the words in the illustration. The first word on the second line is the skeleton of "The"; it is very simple, but correctly executed. Next to it is the correct broad-pen drawing of the word, followed by a more elaborate version. The example on the top line shows how elaborate these letter forms can be made to look, without changes in the bodies of the letters and without reducing legibility.

Contrast between thick and thin strokes is a very basic factor in the beauty of broad-pen calligraphy. You should not be afraid to allow natural variances in pressure between the up and down strokes. This slight difference can reinforce the contrasts. This is not to say, however, that the beginner should strive for such changes in pressure on the pen. It is the direction of movement, above all, that gives strokes their proper weight.

It's a simple rule, but most important: Don't make things harder for yourself by trying to do too much too soon. You'll save yourself a great deal of frustration if you learn to walk steadily before you try to run.

Your introduction to the Italic minuscules begins with the family of letters called the arcade characters. *Arcade* letters all contain arches, as in n and m. At first, you will be most concerned with overall proportion and basic geometry. The first couple of letters should be approached with great care and attention to detail. When you are able to execute them correctly, you will be in control of several shapes and strokes that appear frequently among the letters of the alphabet.

As you progress, each new letter will require fewer and fewer new parts for completion. In fact, very soon you will have to learn little except how to put together familiar strokes in new ways with only occasional, slight modifications. As you approach each new character, the way in which the letters are interrelated is very dramatically revealed, and you'll find it exciting and very encouraging to discover the logic and simplicity behind these shapes that seemed so mysterious when you first took up your broad-nib pen.

BEFORE YOU LOOK AT INDIVIDUAL LETTERS, REMIND YOURSELF OF THESE FACTS:

- In the Italic hand, "vertical" strokes slant slightly to the right.

- All letters contained between the baselines and waistlines actually overlap those lines very slightly.

- It's essential to spend enough time on each letter to understand each detail of its execution. If you rush, you'll make mistakes that will be compounded later when they're incorporated into other letters. A mistake made over again quickly becomes a bad habit that's very hard to break.

THE LETTER N

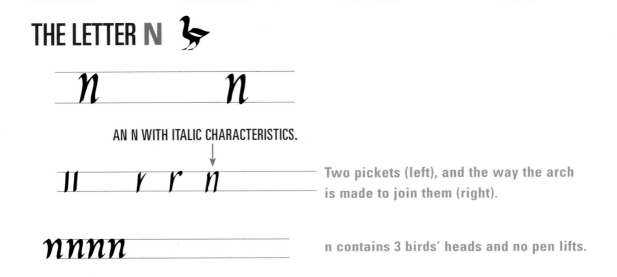

AN N WITH ITALIC CHARACTERISTICS.

Two pickets (left), and the way the arch is made to join them (right).

n contains 3 birds' heads and no pen lifts.

The letter n consists of two pickets connected by an arch. The first stroke is vertical and extends from the waistline to the baseline. After making the first vertical stroke, the pen immediately, without lifting, reverses direction and proceeds back up toward the waistline, curving toward the right. This curve is very slight at first, then increases. It is controlled with care and foresight so that a narrow, tall arch is created. As the pen starts to descend into the second picket, the line becomes straight and continues downward, *parallel* to the first picket, to end at the baseline. It stops level with the bottom of the first picket. If the arch is correctly made, the thickest part of the entire letter will be at the top right of the n. Here you will recognize the bird's head. The thinnest part of the arch forms the beak, and the second picket forms the long neck. The beak appears to be pulling a branch off the left-hand picket. As discussed earlier, learning to draw the bird's head correctly and consistently is indispensable. Don't go any further until you get a feel for it and, once you master it, never relax your careful attention to its execution.

You have now made an n with Italic characteristics, but the complete character must incorporate *three* birds' heads. This may surprise you, but it shouldn't intimidate you because now you know how the bird's head is made. The complete letter n is made like this: Before you make the first vertical stroke, start about one pen width below the waistline and go up and to the right, forming a pointed beak that broadens into a head (just as the arch was made in the first incomplete n). Then move the pen down into the first vertical, and continue as before to complete the letter except for the finishing of the final picket. The third bird's head is made upside down to terminate the letter. This is easier than it sounds. Take your time and trace through the letter with care, and you will get a good mental picture of the letter's proportions. Remember that the thicks and thins of the birds' heads are made without any change in the 45° angle of the pen.

The letter parts you have used to make the n are: the picket, the bird's head, the inverted bird's head, and the arch. (The arch consists of the bird's head and the strip or branch it is pulling away from the adjoining picket.) You should now understand several letter parts that reappear frequently, and you should be able to draw them reasonably well when future letters require them.

THE LETTER M

m *m* *mmmm*

The arches of m may be very slightly narrower than those of n.

The m contains 4 birds' heads and no pen lifts.

The letter m presents nothing much new because it's the same as the n in the beginning and at the end. The added picket in the center incorporates a fourth bird's head, but the letter parts are exactly the same as those you used to make the n.

THE LETTER U

v l u u *uuuu*

THE U HAS 3 BIRDS' HEADS AND NO PEN LIFTS.

The next letter, u, also begins with the now-familiar bird's head. This time, the first picket forms both the neck for the bird's head at the top and the neck for an opposing, inverted, bird's head at the bottom. After making this inverted bird's head, the pen continues in a scoop, or inverted arch, reaching up toward the waistline. At the waistline the pen reverses and descends, making a second picket that again terminates in an inverted bird's head. This letter may look vaguely familiar, and so it should—it is simply an upside-down n. This comparison demonstrates the consistency of form and duplication of shapes that make possible rapid mastery and execution of the Italic hand, to say nothing of its legibility and beauty.

Remember that it is very important in these early stages to spend enough time at each step. Any errors you make in duplicating these early details will be compounded later when they are incorporated into subsequent letters.

THE LETTER Y

y y $yyyy$

The y has 2 birds' heads and no pen lifts.

The y that follows is a simplified version. Later in this book you will see other, more traditional, forms of this letter, but they are special shapes that have less in common than this version with the other letters of this alphabet. The u-shape is duplicated in the body of this y, which has a descender formed by extending the second picket downward and ending it in a flaglike tail. (This new stroke—the flag—appears on either the descender or, inverted, on the ascender, in nearly one third of the 26 letters, so it's very important to master it.) The vertical part of the descender remains straight until quite close to the descender guideline. As the descent ends, the descender then curves to the left and the pen moves straight toward the left. This straight segment of the line should be only one full pen width in length. The flag ends abruptly, appearing to be cut off at 45°, the correct nib angle. The straight part of the flag should not be horizontal with the page, but at a right angle to the vertical strokes or pickets. Since these "verticals" are always slightly slanted in the Italic alphabet, the flag must slant to match. The slant on the flag on the y is therefore slightly upward toward the left. The descender should stop very slightly short of the descender guideline so that the flag won't contact ascenders of the line of writing below it.

THE LETTER H

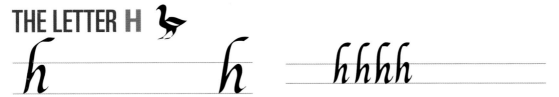

The h has two birds' heads and no pen lifts.

Consider the y again and then visualize it upside down. You are now looking at an h. Because this letter is started at its top right corner, you must begin it far enough to the right to avoid running it into the preceding letter. The first requirement is a straight "horizontal" line (remember that it actually slopes upward very slightly) about one pen width in length. This line is made just below the ascender line. It then promptly curves into a long, slanting, straight stroke reaching all the way down to the baseline. Here your pen reverses to complete the h exactly as you would complete an n, that is, with an arch (including the bird's head), a picket, and an inverted bird's head.

THE LETTER B

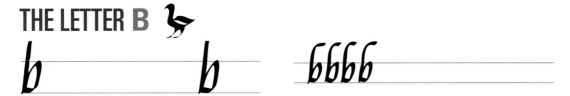

The b has one bird's head and no pen lifts.

Your next project, the b, is very simple because you only need to make another h, with a slight modification. Instead of ending in an inverted bird's head, the final picket stroke turns to the left exactly like the tail of the y—except that the turn occurs at the baseline instead of at the descender line. The shape you're making is, in fact, a flag, although in this case it joins the left-hand vertical picket to make a closed shape.

Examine the way this flag shape contacts the left vertical at the bottom of the b. Although the two picket strokes both overlap the baseline a little, the flat, bottom stroke is slightly angled so that the letter appears level and stable at the bottom. This

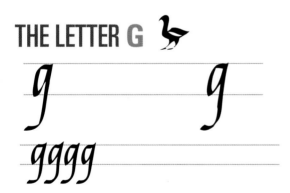

explains the importance of the small but useful spike pointing down from the bottom left corner of the letter. This spike not only stabilizes the character and helps give a level appearance to the writing, it is a very attractive and artistic detail used (among other such details) to lend a sharpness or crispness to calligraphic work. Spikes will be reconsidered frequently as you examine future letters.

THE LETTER G

The g has one bird's head and no pen lifts.

By simply inverting the b you have a good model for the g, which presents you with nothing unfamiliar in the way of strokes. The new features are the direction of pen movement and the order in which the strokes are assembled. The g begins at its top right corner with the same stroke (the flag) that starts the b.

However, instead of beginning at the ascender line, the g begins at the waistline. Remember all you've learned from previous letters: parallel slanting pickets, straight and sloping flag shapes (there are two in this character), and the well-formed bird's head. This time the spike is at the top, and all the details of the top of the letter as they relate to the waistline are identical to those of the bottom of the b as they related to the baseline.

THE LETTER A

In g we have met a member of another obvious family of letters that includes a, d, and q. (They all incorporate the scoop shape, which makes them close relatives of the u and the y.)

THE LETTER Q

There is, again, nothing new about a or q except that a ends in a bird's head on the baseline while q ends in a bird's head at the descender line. Otherwise, they're both made exactly like the g. All the rules about bird's heads, pickets, scoops, and spikes hold for these two letters.

The a ends with a bird's head on the baseline and q with a bird's head at the descender line.

THE LETTER D

The d has 2 birds' heads and no pen lifts.

The next letter, d, is presented here in a simplified form. This d may appear inconsistent with other letters with ascenders that we are studying here. However, it's quite honest, legible, and attractive. It was selected because it's a very logical and simple companion to the two preceding characters, a and q. This d is identical in appearance to the a described earlier, with the exception of the short, straight, unflagged ascender. (Ascenders and descenders of reduced length are sometimes referred to as "extenders.") To make this d, start with the flag shape, go into the first picket, and make the

inverted bird's head and scoop as before. When you arrive at the spot where the a would have a spike, your scoop should have just become straight and vertical. Now this upstroke continues straight upward for about three pen widths beyond the waistline. Here the pen stops without lifting and immediately retraces the ascender as far as the waistline; it parts from the up-curving scoop by continuing straight down to the final bird's head that terminates the right-hand vertical, as in the a. Note the subtle relationship between the long right-hand vertical and the scoop that rises to meet it from the left. This relationship should look just as it does in the a, g, and q.

THE LETTER C

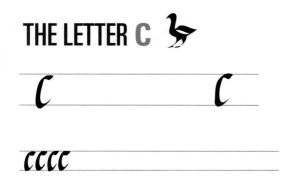

The c is hardly any more than the left half of an a. Remember that it is basically a picket and must not have a round or crescent shape. The top is flat as in a, and the bottom is a bird's head.

The c has one bird's head and a straight spine.

THE LETTER F

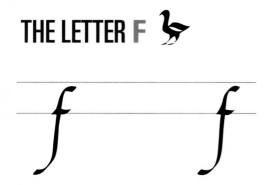

Having made several letters with ascenders and descenders, you should have little trouble with the downstroke or spine of the f, which is a marriage of the two. The cross of the f, however, deserves careful study because it is much more than just a bar across the spine. Like all horizontal strokes, the cross actually slopes downward toward the right, in harmony with the flags on the ascender and descender and the tops of a, g, and q. The slope is

extremely slight, but it's important to make it consistent with the other horizontals. It also makes a very agreeable joining stroke when it's allowed to flow into a following letter. To cross the f, the pen is placed on the existing vertical stroke with the lower corner of the nib's broad edge just level with the waistline. The first stroke is a thin, curving one made downward and to the left until the upper corner of the nib's edge is even with the waistline. At this point the actual cross is made by moving to the right with the standard downward slope. The length of this cross is not fixed and depends upon what adjacent spaces or characters are to be considered, but avoid extremes. Remember that proportions and spacing are dependent upon artistic judgment, not rules. You are urged to evaluate these examples by eye and cultivate your ability to make artistic decisions.

The f is the only letter with a top flag that is actually part of the character and not just an ornament. It's not as high as the other flags you have studied, and this reduced height cuts down somewhat on the extreme length of the stem of the only letter to have both an ascender and a descender. The top flag of the f must never be omitted, although the bottom flag may be omitted—as you will see later in the discussion of double letters.

THE LETTER L

The l has a flagged ascender and ends in an inverted bird's head.

The l is a fairly straightforward character. It is begun the same way as any other letter that has a flagged ascender. It finishes at the baseline in the inverted bird's head.

THE LETTER K

k k *kkkk*

The k is made exactly the same way as the h, except for the h's final vertical stroke. The k, like all letters, should conform to the picket fence pattern as much as possible. The pinch, or kink, in the second vertical stroke of the k is in seeming conflict with that rule, so a compromise is made. The arching curve, which in the h forms a bird's head and neck, is continued in the k to form a loop. This loop should be high and small, as shown. However, the loop need not be completed but should stop just about where it touches the spine of the k. This loop may be imagined as a teardrop that is falling upward and to the right. To make the leg, or final stroke, the pen should then arch away from the spine before moving downward. This arching departure from the spine fulfills two requirements: It imparts some conformity with the picket pattern, and it avoids the dark, ugly area that would result from a rockerlike sagging leg too close to the spine. This final stroke of the k is terminated in an inverted bird's head much like that of an h.

THE LETTER E

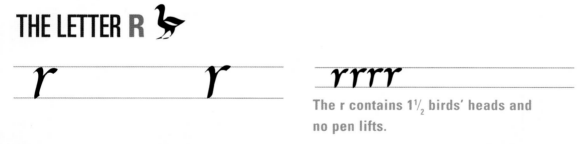

The e has one bird's head and no pen lifts.

The e is related to the k by the teardrop-shaped loop that they have in common. The e is begun with the lower left corner of the nib on an imaginary line halfway between the baseline and the waistline. Motion to the right and downward starts the letter and continues for only one pen width before the loop is begun. The stroke then turns back into a bird's head and is completed by a straight vertical segment. The two straight segments butt together at a right angle. At this point the pen is moving in a straight line, which continues downward as in any other picket and is then terminated in the inverted bird's head. It is permissible, though not necessary, to allow a tiny spike of the beginning stroke to peek out at the left of the vertical stroke. In any case, about half of the initial straight horizontal stroke is "buried" in the descending vertical stroke. Attention to this detail is important to the shaping of the loop and also encourages straightness in the spine of the e. Only a small triangle of the original horizontal remains visible when the character is complete.

THE LETTER R

The r contains 1½ birds' heads and no pen lifts.

To make an r, you simply make an n (bird's head, picket, branch, and beginning of second bird's head) up to the point where the arch contacts the waistline. This is easy. The completion of the r is even easier, but beginners usually have difficulty keeping it simple. At the point where the arch touches the waistline, the curve ends, and the pen continues to the right in a straight horizontal line with the now-familiar slight downward slant. The straight section of this final stroke is only about one pen width in length and is sharply truncated—unless you wish it to make contact with the following

letter or extend into a flourish. The final stroke of the r is the same shape as the flag and the first stroke of the a, but it's made in the opposite direction. This is another example of the interchangeability that makes this alphabet so logical and therefore so easy to learn and to write.

The next four letters, i, j, p, and t, are another logical family, sharing a feature not found elsewhere in this alphabet. This feature is a type of serif that we call the barb. The specific shape of the barb can be recalled by imagining another kind of creature—call it the Lesser Calligraphy Bird. This bird's head suggests that of a blue jay. The beak and crest form a straight line centered on the top of the neck. The barb is begun with the right corner of the pen nib about half its width below the waistline. A thin stroke is then made upward at a 45° angle to a point somewhat above the waistline. Without leaving the paper, the pen reverses its direction and curves downward into a picket stroke. Note that the thin line is not to the side, but is centered on the long axis of the picket. Try very hard to make this shape accurately before proceeding. (The barb of the p is higher than those of the i, j, or t. The barb on the t may even be omitted, because the cross of the t obscures the area where it would be made anyway.)

THE LETTER I

Both i and j begin with the barb and picket. The i ends in an inverted bird's head, while the j ends in a standard flagged descender. The dot on the i is not always necessary, and you can leave it out if the work is quite legible without it, or if you're writing an imitation of an early manuscript done before this feature came into general use.

Both i and j begin with a barb and picket.

THE LETTER J

When you've acquired some understanding and control over these barbs, consider the dots on these two letters. (In fact, they're not really dots but small strokes made from left to right at a 45° angle.) The left end of the stroke is over the vertical line of the letter, like a little pointer to indicate an i or j. Don't center them over the spines of the letters. The purpose of this accessory to the i and j is to avoid confusion with consecutive y's, u's, and other similar picket forms.

THE LETTER P

The same barb shape begins the p. This time, however, the barb is executed entirely above the waistline. The reason for the unique feature is that if the barb were level with the body (or bowl) of the letter the upper left corner of the p would appear crowded. The spine of the pen then proceeds downward, ending in a regular flagged descender. To complete the p, a loop or bowl must be constructed in the same way as the loop of the b. As you remember, the branching away from

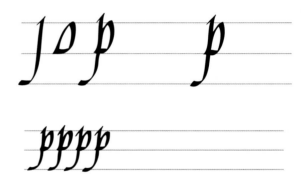

The p has a pen lift—start the second stroke at the baseline.

the spine in making the b is begun from the baseline, where the pen changes direction. To have the same correct branching shape, the loop of the p must be begun from the same level. It is common for beginners to begin too high on the spine and lose that correct shape that suggests a strip being peeled away by the bird's head immediately following. The completion of the loop is the same as for b, except that the flattened shape at the bottom ought to be a little longer for the p, so that a very slight spike is allowed to extend to the left of the spine. This is not a necessity, but it has advantages. It is comparable to the spike that points downward from the b and helps maintain the family resemblance. It also interrupts the extraordinarily long, straight left face of the p.

THE LETTER T

l *r* *t* *t* *tttt*

The t has one pen lift and no bird's head.

to tu ti

Some joins made by the crossbar of t.

The t is next and is the last letter that has a true picket. The t is begun with a very simple barb, without the slight extension to the right of the serif that you have with the i, j, and p. You need just enough movement up and to the right to start the ink flowing before the pen moves downward to form the spine of the letter. If your pen is very dependable and free flowing, you may wish to dispense with this barb. If you do, be sure never to allow the top of the t to curve to the left. The upper right corner of this stroke should be crisp, even a little bit bent to the right, as is encouraged by making the barb.

The point of the spine should rise only about one pen width above the waistline. The picket is finished with an incomplete inverted bird's head. The bird's "beak" is omitted, because it is the crossbar that usually joins the t to a following letter, and such a join is quite strong enough. An additional scooping join at the bottom would be superfluous and probably confusing. The cross of the t is made just like the cross of the f. That is, it starts above the waistline at the same spot where the vertical was begun and curves down to the left before actually crossing to the right. Be careful to keep its top edge approximately level with the waistline, and to remember that all "horizontal" strokes actually slope very slightly downward to the right.

The remainder of the alphabet contains no true pickets, so it's necessary to use various devices to maintain a compatible rhythm and "color" in making them. By employing as many as possible of the other types of strokes and shapes that appear throughout the alphabet, these letters can be made to seem quite at home. The use of these now-familiar shapes will also help you to understand the construction of these letters more quickly.

The two letters v and w consist of up/down zigzag strokes. You will find that they are in many respects almost the same as m and n.

THE LETTER V

To begin the v, make the familiar bird's head, but arch the bird's neck to create a "bent picket" (imagine the bird peering into a bucket of birdseed). The upstroke is made similarly to that of n and ascends before it diverges to the right to become thinner. This means that the thick bottom part of this second stroke will be lost or buried in the bottom of the first stroke. This is very similar to what you did with n. The second stroke, then, will appear to start higher than you might have expected. About halfway up toward the

The v and w each have one bird's head—no pen lifts.

waistline, this stroke (which is a sort of backward s-shape) curves back toward the left. The backward movement here adds weight and strength to the top end of the stroke. This strong top part of the second stroke is basically parallel to the first stroke and is therefore in harmony with the rest of the alphabet in spite of the absence of verticals.

THE LETTER W

Starting with a bird's head again, the w is much like the v. The two center strokes are the only unfamiliar shapes. These are very subtle in shape and in the way they relate to one another. Study carefully the models shown here and pay special attention to their gentle s-shapes. The final stroke is the same as that learned for v. Both the v and the w are made without lifting the pen, with a characteristic seesaw rhythm. A line drawn through a v or through any of the three angles of the w should, if slanted like the pickets of other letters, just bisect each angle. It will take you a while to learn to position the critical first stroke correctly and to achieve consistently the proper slant to these letters without verticals.

THE LETTER O

o *o* *oooo*

The o is not a circle; it has an arch, a scoop, and 2 birds' heads.

Making the letter o means rethinking all your deep-rooted ideas of o as a circle. To make a proper o you must put all thoughts of circles out of your mind. This letter consists of two carefully modified pickets. To begin with, the pen is placed on the paper with the top, or right, corner of the nib about one pen width below the waistline. With a slight initial counterclockwise curve, make a downward pick-

etlike stroke ending in a bird's head. Without lifting the pen, continue upward through the "scoop" shape we have discussed before. The figure so far should be a replica of the lower-left half of the a, d, c, g, or q. The upward stroke is ended in a bird's head at the waistline with the beak just contacting the tip of the first vertical stroke. The meeting of these two strokes at the top produces a shape comparable to the arch of the n. As the bird's head reaches it, the left-hand vertical, which was begun well below the waistline, appears to be complete. Notice that if the top and bottom thirds of the o are masked, the center segments of the verticals appear to be nearly parallel and are only about $1\frac{1}{2}$ pen widths apart.

THE LETTER S

The three thick sections of s are parallel.

Even the s doesn't stand alone; it is a close relative of f and has several features with which you are now familiar. There are three theoretically straight horizontal sections in the s. They are stacked up along an imaginary line that slants just like a regular vertical picket. These three horizontals are each about one pen width long, although the top one is very slightly shorter than this and the bottom one very slightly longer. They all slant down to the right, as do all the horizontals in the Italic alphabet. The middle horizontal of the s is a little higher than center, to produce a bottom hook slightly larger than the top one. There's a catch to the s, however. If you try to follow this precise geometry in a literal manner you will have trouble achieving a smooth and graceful s. It's necessary, therefore, to soften and blend the parts as much as you have to, and to strive for a shape like these examples. Never forget that the idea of straightness at the three key points should influence your making of this necessarily curly character.

THE LETTER X

X X *xxxx*

The x has one pen lift and 2 birds' heads.

The x is also begun with the bird's head, with the neck of the bird slanted like the first stroke of the v or w (another curious bird peering into a bucket of birdseed). This stroke is then concluded with a second, inverted, bird's head. The crossing stroke begins at the top with the flag shape, but in this case the downstroke is angled to the left. This means it must be much thinner than the previous strokes you've made with flags. As this crossing stroke approaches the baseline, it forms another flag, like a standard descender. The letter, as a unit, must appear to have the same slant as the other letters. This requires careful attention to the angle of the first stroke as it is made. Beginners usually make it too slanting and soon find that if the first stroke is angled wrong it cannot be helped by adjusting the second or crossing stroke. The result is an x that is too wide to agree with the other letters. So keep the first stroke of the x quite steep. The second stroke may be made from bottom to top, i.e., left to right, if you prefer. Experiment to determine your preference.

THE LETTER Z

Z Z *zzzz*

Both horizontals of z slant downward.

At last we come to z, which is, strange as it seems, a close relative of f and t. The two horizontal strokes of the z are very much like the cross of the f and t, in that they are slanted slightly downward. The bottom one is just a bit longer and slants downward just the least bit more. It's also centered to the left of the center of the top horizontal so that the finished letter will appear to have the proper slant overall. The connecting, angled stroke must be made nearly straight, but not rigid. The z is a subtle character, and not the mere zigzag usually visualized.

You have now been introduced to the 26 characters of the Italic minuscule alphabet. In the next chapter you will meet the capitals, or majuscules, which are compatible with the minuscules. These are the Roman capitals, and their history goes back thousands of years.

After you have learned to write these 26 letters correctly and uniformly, you may look at the alternative versions given later in the book. Choose your favorites and mix them in any way you like. What is acceptable or not acceptable is a question of what looks good. Nothing is wrong if it is legible and beautiful. However, variety and ornamentation are usually overdone by beginning calligraphers (and by many otherwise skillful scribes). Restraint is always advisable. Remember the time-honored calligraphers' byword: "Disciplined freedom is the essence of it."

THE ROMAN MAJUSCULE ALPHABET

The forms that follow are derived from the classical Roman alphabet, which is the basis for all written and printed letters used to write the English language as well as most of the languages of Western Europe and elsewhere. This alphabet has its roots in the Mediterranean area of over three thousand years ago. By the first century A.D., a thousand years of intelligent refinement by innumerable artists and scribes had brought the Roman alphabet to a pinnacle of excellence. An example of the classic form of that period is still to be seen on a monument in Rome called Trajan's Column. These letters are still studied today by calligraphers, architects, and designers as the most elegant and handsome forms ever evolved for these letters.

The *skeletons* of these letters form the patterns for the following majuscules, or capital letters, which are quite different from the minuscules you have been studying so far. This difference allows the reader to instantly recognize a capital letter among a line or page of minuscules. The two alphabets, however, also have many similarities that allow the two classes of letters to integrate harmoniously.

Beginners are always eager to make "fancy" or flourished capital letters, but you must resist this temptation for a while until you thoroughly understand and can control the basic forms of the letters. The following examples are demanding enough in their simplest forms to occupy your attention right now. Variations galore will be possible later on, and another section of this book will help you study and master some of them.

First, it must be understood that capitals have their own special rules regarding size, proportion, spacing, slant, pen angle, and ornamentation. The following rules apply to the capitals you will study first.

- These capitals are only about $1\frac{1}{2}$ or 2 pen widths taller than the *bodies* of the small letters (not including ascenders). This means that the ascenders of minuscules are considerably taller than the capitals, and the capitals are not as tall as you probably expected—there is a natural tendency to make them too large. (Capitals are more a form than a size. Large capitals used to draw attention to headings, beginnings of pages, and paragraphs are called *initials* and are an entirely new subject that will be briefly considered later.)

- Although the capitals used with Italic minuscules are often slanted, they are just as correct when made vertically. In fact, since the original forms were *not* slanted, this upright style seems more basic, perhaps more dignified, and certainly easier for the beginner to duplicate accurately.

- The "picket fence" with its constant demand for condensed, parallel strokes does not apply to the majuscules, which tend to be nearly as wide as they are tall. The fuller proportions of the capitals offer pleasant relief and contrast to the compact minuscules.

- The capitals fall into families also, but the family groupings do not coincide with those of the small letters. The order in which the majuscules appear in the following pages will encourage you to stay within each of certain family groups for a while before attempting new shapes in other groups. The first six letters consist of straight lines only. As you continue you will be introduced to angles and curves in a methodical progression so that you will not encounter the most subtle combinations until you have had considerable practice with the basics. You will meet six groups or families of capitals in the following order:

Straight and rectilinear letters: I, H, L, E, F, T;
Letters with angled strokes: A, V, W, X, Y, K, N, M;
Letters that are made much like their minuscule counterparts: Z, U, S, J;
Round letters: O, Q, C, G;
Letters with combinations of straight and curved strokes: D, P, B, R.

ROMA

"Capitalis monumentalis," the classic capitals inscribed in stone by the Romans, have an architectural character of their own. They are the parents of all the writing and typography in this book.

Each letter is shown in two sizes: in the size you should practice with your 1.3 mm nib, and in a larger size to show more detail. The larger examples were made with a Parker Italic B nib.

No two handwritten letters are absolutely identical, but all good examples fall within certain limits of height, weight, slant, and curvature, as well as other factors. Your task is to understand and conform to these limits.

Each majuscule is shown with three minuscules as they might appear in a word. The guidelines for base, waist, ascenders, descenders, and capitals show the way these dimensions relate to one another.

TR TR TR

The Roman capitals can be made either vertical or slightly slanted, and with or without serifs. All are suitable for use with the Italic minuscules, but only one style should be used at a time. They should not be mixed. Shown above, left to right, are straight, slanted, and serifed Roman capitals.

Counters, the negative or blank areas within letters or embraced by parts of letters, were discussed earlier in connection with the minuscule alphabet. Because well-balanced counters are important to the success of the capitals, however, we will take a closer look at them here.

A device to keep the color (i.e., blackness) of the capitals more in harmony with the minuscules is to make the capitals lower than you might expect. This makes them bolder, or blacker, in proportion to their size and less in need of heavy verticals.

In both minuscule and capital alphabets, the most obvious counter is the hole in the O. In the Roman capitals, which are shown in the accompanying diagram, D and P have very obvious counters, and if you consider the space below the loop of the P as a counter, this letter can be said to have two counters. B, R, and E also have double counters. K can be said to have three, and so can the letters M and W.

ABEHKPRSXYZ

All the majuscules shown above have one counter above another.

Letters with double or multiple counters—such as A, B, E, F, H, K, L, M, N, P, S, T, W, X, Y, and Z—must always be constructed so that the different areas of white space are in balance. Letters with one counter over the other—like A, B, E, H, K, P, S, X, Y, and Z—must never be divided in the actual geometric center. Such proportions are always visually unsatisfactory. The rule is that the smaller counter is always *above* the larger one, except in the case of the R, where the horizontal is placed in the geometric center of the letter, and the A. The triangular counter at the top of the A must be large enough to balance visually with the open bottom counter.

The making of a correctly balanced capital A requires careful study of good models and then much thought in the actual making of the letter. Look at the example below. Your eye should tell you at once which of the five is correct. This is one of those situations that occur frequently in calligraphy or any visual art, when the good judgment of your eye is as important as your technical understanding of how a letter is constructed.

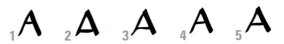

There are, however, certain ground rules to guide you in making the A and other letters with crossbars or "rungs" such as B, E, F, H, P, and R. In order to locate these crossbars correctly you can use an imaginary line drawn halfway between the baseline and the capital line. The center horizontals of some letters are made just above this imaginary line, and others are made just below it. The rung of the A, for instance, falls just below the center line, and so does the rung of the F. The rungs of E and H are just above the center line. These proportions tend to give the characters larger bottom counters, for stability, except where a "hole" exists, as in the lower right quadrants of F and P. In these cases the hole is minimized by having the top counter encroach upon the bottom. In the case of the A, the placing of the rung a little below center helps equalize the triangular counter at the top of the letter with the open counter at the bottom.

You must remember, however, that this line relationship is only a beginner's guide. Study the proportions of the example shown here until you understand how the positioning of each stroke helps balance the letter as a whole. Then your artistic eye will help you maintain fine details of proportion. And don't worry—you can develop that visual ability!

Before you begin to study these capitals you need to clear your head of all your previous ideas about how they should look; you must even put out of your mind (temporarily) what you have learned about the minuscules. Pay close attention to the letters that follow, and memorize their proportions as you look at them. Many rules and measurements will be given here, but instructions in words can't compensate for a visual image before your mind's eye.

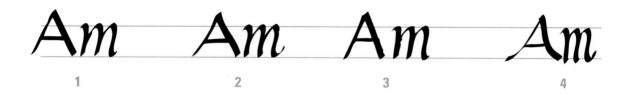

It's important to keep your letters simple until you have a confident grasp of the basic forms. Look at what happens when an inexperienced scribe attempts too much too soon: The two letters above are presented in their basic geometrical form (1) and in their "humanized" versions, which show some natural artistic vitality. A careful and honest beginner might copy 1 and produce 3—an uncertain but true replica. However, a premature attempt to duplicate 2 might look like 4—a waste of ink!

Go back to page 8 and review *The Rule of Letters*. Apply those principles to making the majuscules just as you did to making the minuscules.

As with the small letters, you will proceed from the simple to the complex, so that every new stroke or form can be built upon a sound foundation. Take your time; develop a firm understanding and at least some improvement in execution at each step before proceeding to the next.

The first group or family of capitals consists entirely of "straight" strokes. Careful examination of the models will show you, however, that these strokes have considerable character, and few straight strokes fail to reveal some "spring" or slight bowing, and some specific treatment at the ends.

Don't be too concerned if your letters seem to lack life and vitality at first. Concentrate on overall proportion, proper weight and angle, and so on. Stiffness in the shapes can even be a virtue at the beginning; if you attempt to be too clever too soon, your letters are almost certain to look exaggerated and false.

Capitals are better proportioned when the pen angle is lower than the 45° recommended for small letters. It's often recommended that the capitals are made with the pen held at an angle of 15°. This adds weight to the vertical strokes and generally "beefs up" these open letters that are to be juxtaposed with the tight pickets of the minuscules. The flatter angle also facilitates the construction of details, especially serifs. However, the inconvenience of having to change the angle of the pen can be very distracting to a learner, so the majuscules that follow are made without changing the pen angle, and you should maintain the 45° nib angle while you practice them.

Make all your letters mechanically straight and square, even stiff, until you can control their proportions. Then you can start giving your work some "spring," as seen in the models. Be careful—it's easy to overdo this "spring."

Don't allow the capitals to approach the height of the ascenders. Their height is closer to that of the bodies of the small letters.

The flowing, flourished Italic or "swash" capitals shown later are also made with the pen at the familiar 45° angle (except for certain embellishments, such as serifs, that are obviously not a part of the basic letter).

Serifs are the short crossbars and thickenings that are often made at the end of strokes. Serifs will be discussed only briefly in this book because they have limited application for beginners. The making of serifs requires additional study and the ability to manipulate the pen in different ways. Some isolated examples of capitals with serifs are shown later in the book, but the subject requires a considerable amount of work and instruction after you master the simple forms. Be content for now with these uncomplicated but correct capitals as supplements to your minuscules.

As already stated, the majuscules presented here may have a slant comparable to that of the minuscules, or they may be made vertically and "architecturally" so that even in the same word they stand apart from the minuscules. For now, be very literal in your imitation and follow the verticals, angles, and curves exactly as shown in the examples.

Each letter is shown with several minuscules to show how the heights of the capitals relate to the guidelines and to heights of the ascenders and descenders of the small letters.

Study and compare all four of the models of each majuscule. Look for slight variances in their shapes. Try to combine the best features of all four in your attempts to duplicate them.

THE LETTER I

The correct nib angle for these majuscules is 45°.

Even in the simple form that you are learning here, the first letter, I, is very specific in shape and proportion. Also, since this stroke is included in about one third of the other majuscules, it's very important that you can make it correctly. Notice that the I is 6 to 6½ pen widths in height—that is 1½ pen widths taller than minuscules such as a, o, e, and m, and not nearly as tall as an ascender on a minuscule letter. The ends of the I are beveled at the pen angle of about 45° so that the entire stroke is a parallelogram—a figure formed of two pairs of parallel lines. A slight forward slant to the I is permissible, but it's not advised at this stage of your instruction. The I must not, however, slant backward—not even to the slightest degree. The sharp bottom point of the I should just cross the baseline; this is comparable to the spike made on the small b, and it's a detail that helps tie the majuscule and minuscule alphabets together. Be sure to develop some control over this basic I-shape before you proceed with the next letter, which incorporates two replicas of it.

THE LETTER H

The crossbar of the H is just above the center of the character. **NOTE** the light "hourglass" shape.

The width of the H is about $\frac{4}{5}$ its height. Before placing the first vertical stroke, try to visualize the complete letter on the paper. Make the first stroke on this imaginary outline, and carefully add the crossbar—again on your imaginary form—before making the second vertical stroke. This order enables you to make sure the final vertical contacts the crossbar correctly. The crossbar, or rung, of the H is just slightly above the center of the letter—but no more than half a pen width.

Make several H's very carefully according to the Letters rule, and gain some self-assurance before proceeding. Note that an extremely slight "hourglass" shape adds some grace to the letter H (if done with care and skill), and has the advantage of helping you avoid an accidental—and ugly—"barrel" shape. Don't attempt this hourglass shape, though, until you gain considerable experience and confidence.

THE LETTER L

Under some conditions the L can afford to be the least bit taller than the other capitals.

The L may be made a little taller than other capitals.

The next letter, L, consists of an I with an angled base attached. The L should be only half as wide as it is tall. There is no need to lift the pen while making the L, but the corner of the letter should have a little character to it, as shown. However, get the basic overall shape and proportion under control before trying to add this detail, and remember that you must avoid exaggerating these "character" features in your work.

THE LETTER E

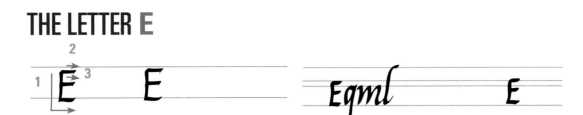

The middle rung of the E is just above the center.

The letter E is similar to the L except for the addition of the top and middle rungs. Place the center rung slightly (half a pen width) higher than the center of the letter, to match the H. As with all "horizontal" strokes, the rungs slope slightly downward to the right. The E, like the F that follows, is about twice as tall as it is wide. The hint of curvature in certain of these strokes should be attempted only with great care and conservatism.

THE LETTER F

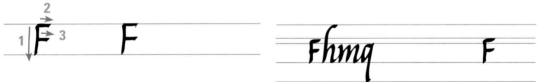

The lower rung of the F is a little below center to balance the open counter in the lower right quadrant.

The F is proportioned like the E and is about twice as tall as it is wide. The F does not have a base rung, as does E, so the middle rung is dropped to just below the midline to compensate for the absence of this base rung and thus to balance the letter.

THE LETTER T

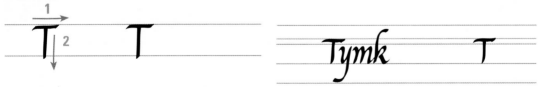

The cross of the T is straight through the middle.

The T consists of a vertical stem like that of the I (and made in the same way) supporting a crossbar that is about $\frac{4}{5}$ the length of the stem. Note that the crossbar is made first.

The second family of capitals includes mostly diagonal strokes and contains the letters A, V, W, X, Y, K, N, and M.

THE LETTER A

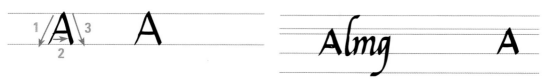

The crossbar of the A must be below the center in order to balance the character correctly.

The A, like the letter T that you have just studied, is also about $\frac{4}{5}$ as wide as it is tall. However, the width is more difficult to estimate in this angled character than in the rectangular shapes of the first group of letters. You must observe this letter carefully and be very particular about developing a well-proportioned replica of the model shown. The rung of the A is not centered, but dropped so that the two counters are pleasingly balanced to the eye.

THE LETTER V

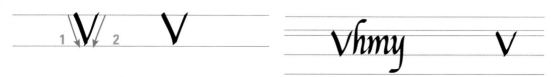

Let the bottom angle of the V just cross the baseline.

The V also is $\frac{4}{5}$ as wide as it is high and is not basically different from the A, except that you turn it upside down and leave out the rung.

Pay close attention to the way A and V overlap the baseline and waistline. Sharp points appear to contact the guidelines (real or imaginary) less securely than do flat bottom letters or those with stable bases.

THE LETTER W

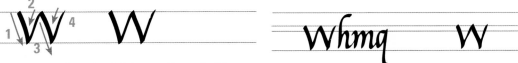

Remember that the W is really two V's.

The W, as the name announces, is a monogram. When the alphabet was being developed V and U were not differentiated, hence "double-U." To produce a W, therefore, you literally make two V's, as shown. The W is not quite as wide as two V's, however, because the center strokes overlap a little at the top.

THE LETTER X

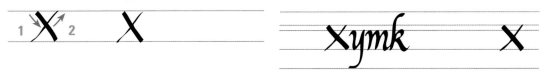

The two strokes of the X intersect above the center of the letter.

The X, again $\frac{4}{5}$ as wide as it is tall, crosses slightly above its center point. This avoids the optical illusion of being top heavy that would result by crossing the two diagonal strokes at midpoint. (If an X that looks balanced is inverted, it will appear to be much too large on top. Try it; it's an interesting experiment.) Positioning the first stroke of the X must be done with foresight. You stand a better chance of success if you mentally project the letter on the page and ink over this visual image. You will quickly discover that the first stroke is the key to the letter; if it's not made at the correct angle the second, upward stroke cannot be adjusted to compensate for the error.

THE LETTER Y

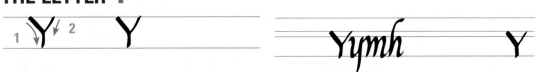

The angle of the Y is just below the center of the character.

Study the Y carefully before you attempt to draw it. The width and height are in the proportion of 4 to 5 as in the V, but the angle of the crotch is more open. Note that the fork occurs well below the midpoint.

THE LETTER K

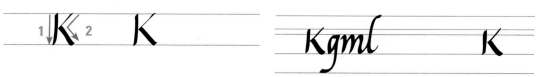

The two parts of the K may show a tiny separation at the point where the second stroke meets the spine.

The spine of the K is the same as for the earlier verticals, like I or T. The arm, or upper stroke, is very slightly curved to add weight at the end of this quite thin stroke. Then, barely touching the spine of the letter, the pen makes an angled departure at about 90° to form the leg. Note the way these strokes relate to the guidelines, especially the baseline. The whole letter is in the proportion of 4 to 5.

THE LETTER N

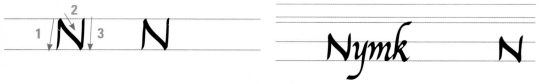

Don't overdo the curvature of the diagonal stroke of the N.

The N is also $\frac{4}{5}$ as wide as it is tall, and the verticals are made like I's. The diagonal is very strong. Don't shy away from it, but it should be "eased" a bit by giving it some "spring" at the top and bottom, as shown. The verticals are sometimes made less bold by rotating the pen angle counterclockwise a little just for these strokes, to compensate for the heavy diagonal. Whether or not you do this depends on your standard pen angle; the more horizontal the nib angle you're using, the more useful the adjustment becomes. A pointed angle at the bottom of the final stroke is a nice touch, but it's more difficult to do and requires some twisting of the nib up onto one corner at the finish. Note the extension of this angle.

THE LETTER M

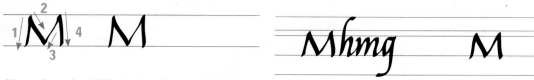

Note that the "V" of the M is not as deep as the two outer verticals.

93

No two strokes of the M are parallel or of the same weight, and none are vertical. The letter is the only one (apart from the W or "double-U") that is wider than it is high. There are three counters in the M. The first has a lean to the left and must be constructed carefully according to the model. The second counter, formed by a V shape, is much wider and is vertical. The final counter must lean to the right and match the first in volume. This last requirement is achieved by careful placement and angling of the final stroke, while looking carefully at the overall shape of the letter.

The next four letters do not constitute a true family, but have in common the fact that each is based on the same skeleton as its minuscule counterpart. They are Z, U, S, and J.

THE LETTER Z

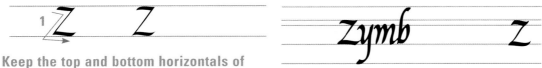

Keep the top and bottom horizontals of the Z strong, not curly.

The Z is about ⁴/₅ as wide as it is high and has down-sloping horizontals. The top stroke is shorter than the base stroke, and centered above it or set enough to the right of it to impart a right slant to the whole letter (if any slant is intended). The horizontals may be enlivened by giving the end of each a bit of curvature, as shown. They should also show some slight slanting downward to the right. This letter requires careful practice. (Don't forget The Rule of Letters.)

THE LETTER U

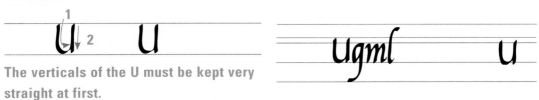

The verticals of the U must be kept very straight at first.

The U, also ⁴/₅ as wide as high, is made on the expanded skeleton of the small u. This version, however, does not begin or end with a bird's head. All strokes may be made downward, even (for a large or very carefully made letter) the small triangular join between the scoop and the final vertical. This is just like the letter I.

THE LETTER S

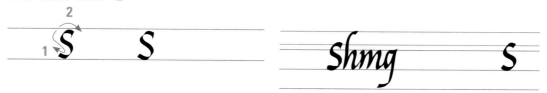

The upper counter of the S is smaller than the lower one. Turn the page upside down to check the truth of this.

In theory, the capital S is the same as the small s. In practice, however, it will look less bold; this is because the character itself is larger but the pen width is not increased to correspond to the enlarged size. The top loop of the s is slightly smaller than the bottom loop. This is another case, as with B, H, and X, of compensating for an optical illusion. (If you make an S with apparently equal counters and turn it upside down, the top counter will look larger. Try it out. It works.) Remember the three short, straight areas that you learned to recognize in the small s—they are important to the capital S as well.

THE LETTER J

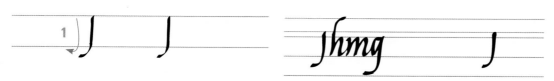

NOTE that the descender of the J is short and ends well above the descender line.

The J is made exactly like the capital I down to the baseline, then it is finished with a flag. The flag, however, is extended less than the flagged descender on the small j. (Remember the short, straight character of the flag stroke, and its slight tilt. Like all Italic horizontals, the flag slopes slightly downward to the right.)

The next four letters are the circular ones. Unlike their minuscule counterparts, they actually are circular, or nearly so, on the outside. The insides, or counters, of these letters are slightly elliptical (egg-shaped) due to the variation in the weight of the pen strokes that form them. All these letters are nearly equal in height and width.

THE LETTER O

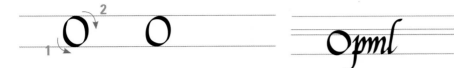

It is acceptable to make the O slightly elongated vertically if you wish.

The O may be round or slightly elliptical. **NOTE** how both strokes of the model are pulled downward.

Carefully examine this model of the majuscule O. It is made of two separate, downward crescent strokes. For small or informal writing it may be made counterclockwise in one full sweep from the top left thin point. Observe the thick-thin transitions and the full, melonlike shape. The thick strokes should be strong and firm. The thins should be clean and sharply matched. Work on the O diligently so that you will be able to approach the other rounded letters with self-assurance. When you've developed some facility in making the O with two separate crescent strokes, you can try making it in one continuous stroke.

THE LETTER Q

You can also make the Q slightly elongated vertically.

The tail of the Q is straight at its center. It should not be curly.

The Q is only an O with a tail. There's no simple version of an O or Q, as there is for other Roman capitals, but a well-made Q in this style will integrate with several other more detailed or formal capital alphabets, so don't proceed until you have reasonable control over it. The tail is a very sensitive feature, and the slightest suggestion of crudeness will ruin the entire letter. The pen starts the tail in the lower left quadrant of the O shape. The stroke is nearly straight at the beginning, quite straight through its center, and slightly curved upward only at the tip. This strong, black stroke should be firmly made.

THE LETTER C

The spike of the C is made by pulling the left corner of the nib down very briefly.

The letter C is as wide as it is tall. The first stroke of C is like that of O or Q. It is strongly pulled, perhaps even more than the closed-counter letters. The top stroke starts at the upper left, like the second part of the O, but the shape is changed immediately as the pen moves to the right and it becomes an almost straight "brow" to the letter. The final stroke may have a slight spike, similar to S, as shown. Experienced scribes, when writing rapidly or informally, often start at the brow (the upper right corner) and make the C in one full stroke.

THE LETTER G

The final stroke of the G is a symmetrical angle shaped like an arrowhead.

The G is also as wide as it is tall and is begun like the C. The first crescent stroke has the same strong pulled quality, but ends up slightly shorter, flatter, and lower to allow for the addition of the final stroke. This final detail is a symmetrical bracket, which, viewed by itself, resembles a broad arrowhead. It forms a right angle and touches the bottom of the crescent, forming a join at the thins. The G, like the C, may be begun at the brow and the body of the letter made in one full stroke. The bracket, however, is always a separate stroke.

The next four letters, which conclude the majuscule alphabet, combine straight spines with crescent curves. They are D, P, B, and R.

THE LETTER D

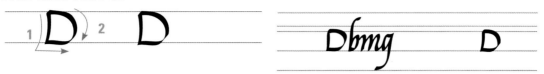

Keep the spine of the D stiff until you develop some skill.

The D begins like the L, but the bottom arm of the D must have a slight upward curve at the finish. The bottom arm is straight and slopes downward (like all "horizontal" strokes) until the final third; here it must rise to the point where it will meet the second stroke of the letter, which descends from the top. This second stroke starts at the point where the first stroke was begun. Both of these strokes curve outward very subtly at their common point of origin, forming a very slightly acute angle that at a glance appears to be a right angle. (This treatment is desirable in most cases where straight or nearly straight lines meet or depart at a 90° angle.) The top stroke of the D is essentially a crescent, like the top of the O, once it departs from the flattened top. The crescent should repeat that strong, flattened, boldly downturning shape described for O. The crescent meets the upturned bottom stroke at the point where both are thinnest. The D is approximately as wide as it is high.

THE LETTER P

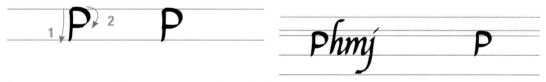

The top counter of the P is larger than the bottom one.

The P is about half as wide as it is tall. P starts with a spine nearly identical to a simple letter I. The bowl of the P should repeat the character of the D described above, but because it's smaller it cannot be flattened as much through the crescent. The top corner should be like that of the D. The bottom of the bowl is flattened as it enters the spine. (This horizontal can be made to join the crescent from left to right in more formal or larger work.) The final stroke meets the spine just below the midline. This lowered position compensates for the void in the lower right area of the P. A similar technique is used with the letter F: The crossbar of the F is slightly lowered to compensate for the open space at the bottom of the letter.

THE LETTER B

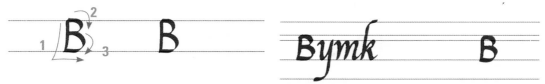

For a correctly balanced letter, the bottom counter of the B must be larger than the top counter.

The parts of B are very closely related to those of D and P. The L-shape is made as for D, except that the horizontal is slightly shorter. The upper bowl is begun as for D or P, but is even smaller than the bowl of the P. This upper bowl has no horizontal closing stroke at the bottom, but stops at its thinnest point; this is where it will be met by the bottom bowl. The bottom bowl begins just above the midpoint of the spine and is drawn similarly to the crescent of D and P. The bottom bowl is slightly taller and slightly wider than the top one (slightly is the key word here). The finished B is half as wide as it is high. Remember The Rule of Letters, and pay close attention to all the details that you can find by examining the models.

THE LETTER R

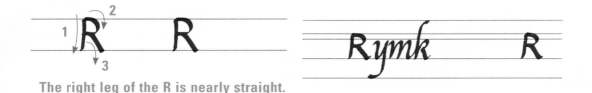

The right leg of the R is nearly straight.

The final letter has been saved for last because it combines straight, curved, and angled parts. The leg of the R is almost a flourish and can easily be extended into a spectacular ornament. The R is half as wide as it is tall except that the leg may be extended a little to the right. The R is constructed according to the principles used in the last three letters. The bowl is left unclosed at first, as for B. The horizontal rung is made from left to right and is the only horizontal in the capital series that falls midway between the top and bottom of the letter. At the point where it contacts the crescent, it angles downward abruptly. The right leg is strong, straight, and bold. It may curve up at the very end, but this is a very sensitive maneuver, and you must always err

on the side of caution. Keep your mind on the whole letter as you add the leg to make sure that the completed R is stable and balanced. Eventually you should be doing some very handsome things with this stroke, but keep it simple at this stage of your progress.

You have now been introduced to 26 minuscules and 26 majuscules in the Italic tradition. This means you can now write anything you like in English—and in most other languages. By now you will understand why we said at the beginning that it's not intricacy and fancy strokes that constitute calligraphy. Discipline and control enlivened by thoughtful, restrained freedom are the marks of a calligrapher worthy of the title. Be content to do what you have mastered without risking failure by trying to add some feature you have not yet tamed. Proceed slowly. Keep your mind and eye on the paper as well as your hand and your pen. A wandering mind or eye precedes a wandering hand and pen. Automatic hand movements won't produce fine letters. The proper stroke must be clearly visualized in your mind's eye before that stroke can emerge from your pen.

A rather extravagant capital, or initial, but fun to try and a good practice exercise. Redcastle is an ancient city in Scotland, where the modern resurgence of calligraphy has been strongly supported.

NUMERALS AND SYMBOLS

NUMERALS

11 22 OO

The only numerals without extenders are 1, 2, and 0. They are made without pen lifts. The zero, however, may be made in two strokes, like the capital O that it duplicates—except that it's smaller.

33 55 99

The digits 3, 5, and 9 are a family, with identical extenders below the waistline. The only pen lift in any of these numerals is made when placing the crossbar on the 5.

66

The extender on 6 imitates those of 3, 5, and 9, but is made at the beginning rather than as a finish to the figure. There's no pen lift.

The Arabic numerals, as adapted to the Italic hand, are very specific in their forms and may seem oddly proportioned when you first look at them. They are, however, well designed and should soon endear themselves to you. These numerals are derived from a writing system entirely alien to the Roman ancestor of our alphabet, and despite long use and considerable adaptation they still reveal a different flavor from the Italic letters. These figures have a "dancing" quality that results from the several "extenders" (abbreviated ascenders and descenders) that appear in the series.

Try to duplicate the following numerals *one at a time* with your pen. When you have made some progress with 1, spend some time with 2, and so on. Always be sure to make at least a *little* progress at whatever you attempt before moving on to some other challenge. The following tips should be useful in helping you make these numerals.

44 77 88

Digits 4, 7, and 8 are subtle forms.
NOTE especially the following points:

- 4 is broad and open, and rests on the baseline. The pen is lifted before the vertical stroke is added.

- 7 must balance gracefully on its one leg. There's no pen lift.

- 8 is not two circles, and the counters are unequal. The 8 may be made without a pen lift.

- The 1 has a barb at the top and a leftward spur at the bottom.

- The 2 is quite wide, rounded, and firmly based. The base slopes downward to the right, and is straight except at the very ends. It is thin at the beginning.

- The 3 has a small top counter and a large bottom counter.

- The 4 rests its horizontal bar on the baseline; this stroke is sloping and otherwise agrees in character with the horizontal base of the 2, as shown.

- The 5 is shaped like 3 at the bottom and the top bar is very similar to the horizontals of 2 and 4.

- The 6 is a circle, smaller than a zero, with a tail that makes the completed figure taller than a zero. The tail is an extender.

- The 7 has a horizontal that in character is very like those of 2, 4, and 5. The vertical is tilted enough to give the entire figure an appearance of being slanted at about 5°. A bar may be drawn through the vertical for the sake of legibility (especially for modern Europeans), but this is not consistent with formal Italic writing.

- The 8 is *not* two circles, but resembles two teardrops, point to point. The top counter is slightly smaller than the bottom one.

- The proportions of the 9 are similar to those of the 6.

- The zero is not like the small o you studied earlier, but does resemble the majuscule O in shape. It is circular on the outside and has an elliptical (egg-shaped) counter.

Give these numerals the same attention you gave to the two alphabets. By now you should be sufficiently confident in the use of your pen to be able to make these characters well without too much trouble.

In the 15th and 16th centuries, it was common to use Roman numerals with Italic writing. Capitals were often mixed with small letters and, unlike today, Roman numerals were commonly written in minuscule form. Where i's, each representing "1," were used, the final 1 was tailed like the modern j. The following forms were commonly used.

1234567890

The preferred style of Italic Arabic numerals.

1234567890

An alternative style.

1	i or j	16	xvj
2	ij	17	xvij
3	iij	18	xviij
4	iiij or iv	19	xviiij or xix
5	v	20	xx
6	vj	30	xxx
7	vij	40	xxxx or xl
8	viij	50	l
9	viiij or ix	60	lx
10	x	70	lxx
11	xj	80	lxxx
12	xij	90	lxxxx or xc
13	xiij	100	c
14	xiiij or xiv	500	d
15	xv	1000	m

The early Arabic numerals evolved in Europe into quite different forms. The evolution of our first three digits is shown here.

In Roman numerals the following historic years would appear as follows:

1066	*mlxvj*	1943	*mcmxliij*
1522	*mdxxij*	2001	*mmj*
1776	*mdcclxxvj*	1983	*mcmlxxxiij*

1066	mlxvj	1943	mcmxliij
1522	mdxxij	2001	mmj
1776	mdcclxxvj	1983	mcmlxxxiij

SYMBOLS

Students have a tendency to make punctuation too heavy-handed. The examples shown here are made in a light style, and this style is recommended to you. The quotation marks, comma, and exclamation mark are all made with a flicking downward motion of the pen that produces the pointed shapes you see. If you want to lighten certain of these verticals, you may turn the pen nib counterclockwise a bit. For more definite shapes, the pen may be rotated clockwise as the flick is executed. The right corner of the chisel nib drags the last bit of ink out until it disappears, making a very sharp, dry spike.

EXAMPLES OF PUNCTUATION.

Exclamation! !!! !!!

If you are a bold writer, periods may be diamonds. However, a short dash made with a touch of the nib is quite acceptable.

(parentheses) Dash —
period. ❖ semicolon ;
Hy/phen ❖ Quest ?
Slash and/or comma,

Parentheses may be made with the nib held at a 90° angle to the writing line.

The ampersands, or "and" signs, are made as shown. They are ciphers for the Latin "et" meaning "and." These ampersands are very universal, traditional, and convenient. Some are much larger and more decorative than others, so that you can choose one design for use with capitals while another may be more appropriate to a line of minuscules. Study these symbols and practice them by the same methods recommended for the alphabet.

Punctuation should be used sparingly and made with a light hand. The very light double hyphen shown in the illustration demonstrates this unobtrusive method of punctuation; it is barely visible on the page except when the eye actually reads it in passing. The width of this hyphen can be varied to help adjust the length of lines when you wish your text to be "justified," i.e., flush and even at the margins.

Use punctuation only when it's really necessary in order to clarify the sense of the text. Take care to keep the symbols under control and in alignment with other features of your writing so that the pattern is not disrupted. Later, when you develop more skill, you can experiment with changing the angle of your pen in order to make lighter brackets, quotation marks, and other symbols, as has been done in the illustration.

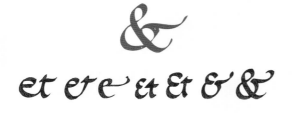

Some variations of the ampersand, showing how it evolved from the Latin et & Et.

JOINS AND DOUBLE LETTERS

Italic writing is traditionally joined. That is, most letters in a word are in contact and appear to have been made with a minimum of lifting the pen from the paper. The result is a more rapid hand, and words and lines that hold together for increased beauty and legibility.

Now that you have an understanding of the characters of the Italic alphabet, you can start joining them to make words. At first you should make each letter as you have already learned, with careful attention to spacing. The spaces between letters should be about the same as the spaces between the vertical strokes within letters. For example, mnm consists of eight pickets in a fence, nearly equally spaced. You will notice that the points of the birds' heads often touch. Some that don't may be made slightly longer so that they blend into the next letters.

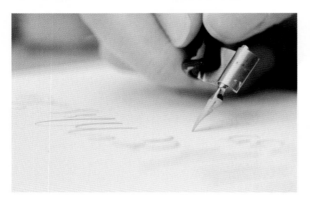

fat fat fat fat fit fit
to to to beg beg led led

slow slow slow own
egg egg claw claw
rapidly written, cursively

Various ways of joining—and not joining— letters in the Italic alphabet.

When joining letters you'll find that you can sometimes dispense with the bird's head, when your style is very condensed or when the bird's head makes a join look complex or "fussy."

run run rye rye

NOTE the improvement in letterspacing where the bird's head is omitted.

A good example, as you can see from the illustration, is when an r is followed by a u or another letter that ordinarily starts with a bird's head. When r is the first of a pair of joined letters, the bird's head would extend the space between them, which is already more than adequate.

Most joins are scoops, as in the small u. The beak of the bird's head is allowed to extend to a point where the next letter, properly spaced, will touch it. Some letters do not join at all, unless another letter provides the connection; these are b, g, o, q, and s. Often, t and f join by extending their crossbars. There are exceptions to most rules, and joining is not ruled by hard laws. By observing examples in this book and in other sources, you will soon develop a sense of what works and what does not. The illustrations here show some identical combinations handled in different ways—all acceptable. More joining possibilities are demonstrated in the following discussion of double letters.

Double-extender combinations—like ll, lk, ff, or tt—sometimes present esthetic problems and may benefit from the correct special treatment. A pair of double ascenders, as in *balk*, or a pair of double descenders, as in *type*, are more attractive if one of the pair is modified. If a pair of letters with double ascenders or descenders are written conventionally, the flags may form an attractive boxy shape.

Strategies for handling double letters and double extenders.

balk ty balk ty balk

type to type tu type

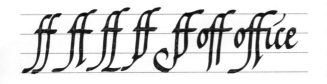

Because the Italic f has both an ascender and a descender, the box created by an unmodified pair of f's is particularly awkward.

The solution to the problem is to avoid contact by omitting the flag, or by offsetting the flag so that it makes contact with the adjacent ascender or descender. It's always the first ascender that is made shorter and allowed to butt into the second, taller ascender, as in these models. In the case of descenders, it is always the second that is made shorter. Frequently a barb or a serif is added to give a more finished appearance to the modified stroke.

Sometimes you encounter triple ascenders or descenders, and these require even more care. Note, however, that certain words that may seem to present a problem are actually quite manageable. For instance, *Egypt* has three descenders, but the descender of the g is separated from the descender of the y by the body of the y, and therefore does not present a problem.

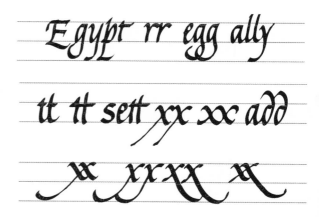

The examples shown here are self-explanatory, but you should study them carefully to see why they work so well, and how balance and flow are achieved in their execution.

Pay particular attention to the parallel treatment of the vertical strokes, and the way the flow of the "barbed" ascender conforms to the shape of the "flagged" ascender, especially at the very top. The flag seems to continue sweeping over to the right, while the barb only suggests a tendency to follow, but there is a lovely harmony in their flow. This small but beautiful example is what is meant by calligraphy.

The term ligature is used to describe either a line joining two letters or a pair of letters that have been joined to form one unit. Common examples of ligatures are ff, ll, fi, and ty. The shapes of the letters in these combinations are often modified dramatically (as you have just seen in the treatment of double letters), and result in some very beautiful calligraphic constructions.

The illustrations here include examples of ligatures that can be used in problem letter combinations, such as where you have double or even triple ascenders or descenders.

The large ligatures between such letters as c and t, c and h, s and t, and s and h are affected developments of casual, accidental "drag" strokes from the second or top stroke of two-stroke versions of the c or s; these strokes are made after lifting the pen from the bottom of the first part of the letter. The pen is not lifted after topping off the s or c, and is dragged into the next letter.

VARIATIONS ON THE ALPHABETS

The alternative letter forms presented in this chapter add variety and interest—even speed—to your calligraphic hand. Some are admittedly more traditional, more legible, and more beautiful than those you've already learned. They've been reserved until now, however, to allow you to concentrate on simpler forms without being distracted by more strokes and shapes than necessary.

These variations are more sensitive and more difficult than the basic series, so be cautious and deliberate as you study their subtle proportions. A minor flaw can result in a completely failed effort.

It's not necessary to duplicate each of these often freely written examples exactly, but at first you should try to be very imitative. By imitating, students develop understanding and control. Eventually, as with all scribes, your own personality and taste will lend your hand a unique quality. You can then incorporate into your work both forms and flourishes that you've admired in the work of others and those you invent or evolve yourself. Remember, though, that the beginner who indulges a taste for ornamentation is skating on thin ice. Always try to be conservative and to not exceed your skill and understanding at each stage of your progress.

SOME ASCENDERS AND DESCENDERS WITHOUT CONVENTIONAL FLAGS.

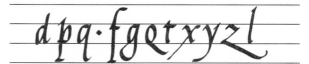

As you discovered when you began to study calligraphy, you do better work when you don't try to run before you can walk. The same principle applies when you begin to experiment with variations. Take care not to go beyond your depth, and remember that good taste is never flamboyant and that a conservative approach is your best defense against excess.

Smaller versions of the Roman capitals may be used in words or phrases integrated among the lines of Italic text. They may be used to add emphasis or set certain ideas or passages apart just as italics are used in a regular "book hand" alphabet to draw the reader's attention to a certain word or idea. These "small caps" may be the same size as the minuscules, or they may be very slightly (about half of a pen width) taller.

Small capitals must be well formed according to the rules learned for the large capitals. They should not intrude on your eye or "jump off the page"; they only announce that the reader is encountering a message that for one reason or another merits particular attention. Small capitals should be very regular in pattern and more vertically oriented—in contrast to the minuscules, which are, of course, made on the slanting picket pattern. The small capitals should also be very conservative, without flourishes or ornaments except on the edge of the block of writing, as in this example. Serifs are not recommended with the small capitals.

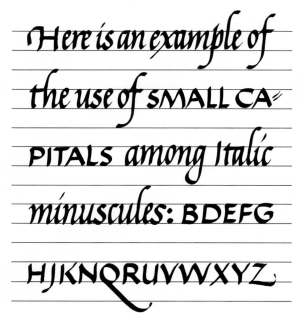

This sample demonstrates how consistent an effect can be achieved by juxtaposing small capitals with Italic minuscules. Note that there are three carefully controlled flourishes in this piece, in the initial H and in the q and z in the last line—that's a lot! Don't overdo it.

Examples of Roman capitals with built-up serifs, suitable for initials and very formal inscriptions. The construction of the A is diagrammed—small fillets at the lower right of the verticals are added as short, curved, extra stokes. This style may be used to begin pages or paragraphs or to make very formal headings or titles.

Serifs are small cross-pieces that terminate some strokes of some letters. They serve the same purpose as the bases and capitals of architectural columns: that is, they provide ballast and support and define the limits of the lines. They also serve to add weight to the capital letters and to differentiate them from the minuscules. Capitals are often regarded as architectural forms, and the most dignified and sophisticated versions of the capital alphabet require these details to give them stability, interest, and elegance.

In order to give balance to a letter, the serifs must themselves be in balance. So serifs, in their various forms, deserve as much attention as the basic shapes of the letters of which they are a part. As with skeletal strokes, serifs must have no curves or elongations that are not carefully planned and skillfully controlled. The worst mistake you can make with serifs is the same one that occurs when you start drawing basic letter shapes—making squiggles or curves that aren't properly planned and understood. As with the letters, you must carefully examine and learn from good models before you try making serifs, and you must compare your work with the model until you are satisfied that your duplication is accurate.

There are many models of letters with simple serifs that you can copy, both on this page and farther on in the book. As a beginning calligrapher, you are not asked to create expert, built-up serifs like the most sophisticated examples shown here. In fact, we don't even ask you to make serifs at all until you progress beyond the level of this book. However, you can start here to practice simple serifs, even though you probably won't want to include them in your finished work at this stage.

Begin by making straight "slab" serifs, as shown, and don't complicate matters until you can make well-balanced capitals with straight, stiff, but well-proportioned slab serifs. To do this successfully is no small achievement, and it's a necessary step on your way to more ambitious efforts.

Examples of "stuck on" slab serifs (top), more flowing serifs (center), and Italic "swash" capitals (bottom). More swash capitals may be seen later in this book. The rubricated (red) letters illustrate a traditional use of color.

It's interesting to note here a relationship between the serifs employed in the Roman alphabet and a technique employed by Asian scribes, who write with brushes instead of pens.

The Chinese and Japanese admire a quality in their calligraphy that they call "bone." Scribes employed in writing these languages include in their work very skillfully made strokes with boldly weighted beginnings and ends that work much like the Roman serifs to attract and arrest the eye and invite the reader. These strokes (even though they are made with a brush instead of a pen) have strong straight shafts and confident, definite ends. They resemble silhouettes of bones . . . hence the name.

The Asian connoisseurs of this writing admire such vigorous calligraphy and say it has "lots of bone." The same principles apply to our Italic characters. Straightness, strength, and confident beginnings and ends (serifs and birds' heads) give the Italic alphabet character and beauty. This comparison of two apparently alien forms emphasizes the universality of artistic principles, and if you keep it in mind you will be more likely to avoid weak strokes and indefinite shapes.

Each character signifies an idea, and may be read in any language by someone who has learned the symbols. These characters are part of a writing system, which, although very alien from our own, displays several artistic features that are common to all good design—including the Italic hand. For instance, the strokes of Chinese writing are strong, straight, and firm—as our Italic writing should also be—and have weighted terminations that resemble serifs. (The bird's head that is so important to the Italic hand is a sort of serif and adds weight to the ends of picket strokes.) There is a harmonious relationship between thicks and thins in Chinese as in Italic, and in each the horizontals are essentially parallel and show a slight slope. In the Chinese characters the strokes are all made in a logical and calculated order, mostly from top to bottom. Italic stokes are made in similar sequence, mostly from left to right.

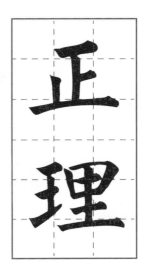

Here are two Chinese ideographs chosen for their quality of "bone" and their seriflike features. The characters are shown on the grid used by learners to calculate size, proportion, and spacing. Each character occupies a square. Note the sloping horizontals, reminiscent of Italic writing. The translation is "Right reasoning" or "Correct philosophy."

FLOURISHES AND ORNAMENTS

An occasional variation, such as an elegant capital, an angled tail on a q, or a deliberate flourish, is an attractive feature in a piece of calligraphy. As you become more confident, you'll want to introduce these elements into your own work. Always keep in mind, however, that excess is the scribe's worst enemy. The best work is held together by its disciplined regularity. Flourishes and other distractions, carefully placed, enhance your work, but too many of them crowd and confuse your lettering. And, as stated very early in this book, an elegant flourish won't make calligraphy out of a poorly executed piece of writing.

When you make these flourished capitals, rotate the page so that the thin strokes may be made from upper right to lower left or vice versa. Note the tendency to straightness in the strong strokes. The tail of the Q is straight almost throughout its length.

These characters, with their decorative flourishes and colored embellishments, were all done without altering either the nib angle of the pen or the arm and hand positions to which you are now accustomed. In almost all cases where the strokes appear to have been made with the nib held at an angle other than 45°, the effect was actually achieved by moving the paper. By keeping the hand and nib positions constant, but rotating the paper, you can use easy and familiar movements to make the different thicknesses needed. To make the ornaments you see here it was necessary to turn the paper back and forth frequently and to use several pens loaded with inks of different colors. When you're starting out, however, it's distracting to change pens all the time, so when you copy and practice these designs you'll find it much easier to use just one pen loaded with black ink. Once you've mastered the shapes you'll be able to repeat them, substituting the colors of your choice.

When you start to use color, it's important to consider the order in which colors are applied. It is generally best to do all the black first, but where a colored stroke is to cross a black one, the black ink must be completely dry before the color is applied. Even then, there's a danger that the black will dissolve into the color and muddy your entire effort. You can prevent this kind of contamination by placing some of the color strokes first, by passing rapidly over intersections, or even by interrupting some strokes so that the different colors do not actually touch at all. Close, parallel strokes usually look best when the separation between them is extremely small and appears as a thin hairline of white against a pigmented background.

The ornament shown here in gray may be made in bright blue or green. The tendrils are made by dragging the ink on one corner of the pen nib in one continuous movement.

Some of the larger swirls that you see here were made section by section instead of all in one piece as they appear to have been done; in some cases the nib angle has also been changed slightly. Graceful, sweeping "display" calligraphy is not usually as spontaneous as it appears. A flourish may look like a wonderful, rapid sweep of the pen, but in fact it has been carefully thought out and executed. So when you begin to experiment with this style, do everything slowly and deliberately at first. It's much better, at the beginning, to produce stiff, too-angular attempts than free-swinging exaggerated forms that lack control.

The thin curly tendrils at the ends of some strokes are made by turning the nib onto one corner and "dragging" the last droplet of ink out into a diminishing hairline. This is done in one continuing movement as part of the "parent" stroke, and it takes careful practice to be able to do it well. The thin straights are ice-skate strokes, done from upper right to lower left or vice versa. Remember that it is nearly always the angle of the paper, not the hand or pen, that is adjusted for these ornamental strokes. Do not be afraid to move your paper around to get the effect you want.

Red
ornamentatio

An elaborately ornamented initial like this can be used to beautify an inscription and to draw the reader's attention to the opening word. You may use whatever colors you wish—including real gold leaf. The serif at the bottom of the spine of the R was filleted with a small extra stroke. The fine lines were done with a pointed nib, not with the broad Italic pen.

Note that except for the flourishes themselves, these ornamental letters by and large retain the basic shapes that were described earlier in this book. The main bodies of nearly all these letters (that is, the parts contained between the guidelines) conform to the standard patterns for the minuscules and majuscules you have studied in simple forms; it is usually the ascenders, descenders, and other appendages that are flourished.

It's a mistake to get involved in this kind of decorative work until you are fully familiar with the basics and in confident control of your pen. The freedom you want to give your flourishes will become chaos unless your hand and eye are trained well enough to hold the work together. Approach decorative work with respect. And practice patiently. Use your mind and eye even more than your hand and pen. The *Rule of Letters* on page 8 is just as effective in teaching yourself decorative shapes as it is in learning any of the other calligraphic forms.

When you are making these forms, you do not change the 45° angle of the pen. The weight of the strokes tells you which way to turn the paper to produce the desired degree of thickness or thinness. Use various colors to discover which combinations are most pleasing. The reds, blues, and greens should be light and brilliant—the effect should be joyous.

BEAUTIFUL THINGS TO DO WITH CALLIGRAPHY

The following pages offer a number of ideas for practical and attractive projects that give you a chance to put your newfound calligraphic skills to use. There's nothing in this section that requires techniques that haven't been covered—at least briefly—in the earlier chapters.

You will see that, with the ability you've developed so far, you can find a considerable range of applications for your skill—from simple name tags and notices, to invitations, announcements, flyers, posters, texts for framing, even letters to your friends.

Note that although the size may differ, the overall proportions of the Italic characters remain the same for any size of writing instrument. Larger nibs give wider broad strokes, of course, but usually the thin strokes do not increase proportionately; therefore broader nibs tend to produce letters with greater contrast between thicks and thins. This is an advantage, as this contrast is essential to the crispness for which you are striving.

After you become more proficient, you may decide to write Italic exclusively. An everyday hand, to be rapidly written and of a reasonable size, should be done cursively, and with a narrower nib. The results will be an informal hand with less fine detail, but still characteristically Italic and still superior to the round hand, which often becomes illegible when written quickly. By using a narrower nib (no wider than 1 mm) you can write smaller, and the making of arches and scoops can be done with very short up and down movements to preserve the classic Italic picket pattern.

Reduction of art

Reduction of

These examples are the exact size of the original writing.

Reduction of art

Reduction of

This is the same pair of examples reduced to 50 percent of the originals.

Minuscules of about one-half inch in height are ideal for displaying calligraphic virtuosity and can be made smaller in reproduction if the work is to be printed. The reduced image will be flattered by preserving all the fine details of the large original work, which would be largely lost if written with a smaller nib.

When you're preparing art for reproduction, you have much more control than when the original is going to be on display. Corrections are easy because parts can be cut out, replaced, repositioned, and so on. The only critical values are those light enough to disappear or dark enough to reproduce. Cut edges, lines made with a blue nonreproducing pencil (available at art stores), smudges, scratches, and wrinkles are of no consequence if the camera cannot "see" them. **Note:** Color photocopiers will "see" the non-reproducing blue marks.

An entire text, if it is to be printed, can be written without regard to layout, then cut into strips and pasted on a ruled sheet. Words may be respaced, errors corrected, or parts rewritten, and the completed original piece may be a crazy patchwork of over-lapping paper scraps. As long as the black and white areas are distinct, a flawless reproduction is possible.

The edges of patches may cast shadows that the camera can pick up, so try to keep all edges pasted down flat. Use thin paper to write on, then mount it all on a stiff board. Rubber cement can be used for mounting. Spray adhesives of various sorts are avail-able in art supply stores. These can be rubber-based or wax-based. Most are good, although some spray cans tend to clog with some rubber-based adhesives. Don't use water-based adhesives, especially around soluble inks.

White water color (called "opaque white" by artists) can be used to cover small unwanted, inked areas. However, this is neither safe nor easy with water-soluble ink as the black and white pigments tend to run into each other. It's much easier to use a scrap of white paper with adhesive on the back; this makes a good opaque patch and can be cut to fit a small area very neatly.

Folded ribbon

The ribbonlike thicks and thins characteristic of Italic writing are formed by single strokes of the broad pen. The angle at which the pen is held does not change. The differences result as the pen changes direction.

When you're preparing work for reproduction, remember the following points:

- Black ink on white paper gives sharp contrasts and is recommended for a piece of art that is to be reproduced by a printer, even the parts that are to be printed in another color.

- Guidelines, margins, and other details that you don't want to show on the finished piece may be drawn with a blue nonreproducing pencil. These lines need not be erased from the completed work because the camera will not pick them up. Use a very sharp light blue pencil and press very lightly to avoid damaging the quality of the writing surface. These blue pencils are also somewhat waxy and may resist the ink.

- Put your work on an oversize board or sheet of paper, and use nonreproducing blue rules to mark where it should be trimmed. Write your instructions to the printer in the outer margin.

- Especially if it is large, back your art with a board stiff enough to guard against damage; cover the art itself with a tissue or other protective paper, attached at the top with adhesive tape. Instructions to the printer can also be written on this protective sheet.

- If your writing was done in water-soluble ink (the type usually used in fountain pens), be sure to caution the printer that this is a vulnerable piece of art to be handled with extra care. Write this caution right on the protective flap: *Careful—not waterproof ink*.

- If the piece is to be folded (into a card, for instance), show the fold with a broken blue (nonreproducible) line marked *fold here*.

- If you are selecting paper to be written on—such as for a form or citation that will be printed and then filled in later with the name of the recipient or other information—choose the paper very carefully. Try your pen on a sample before you give your approval.

When you look at the samples on the following pages, you will notice that the rules of spacing that you learned earlier for making letters and words apply equally to pieces of work for display. The proportion of black to white—or writing to background—is carefully maintained, and margins are generously proportioned. The two layouts presented are very classic shapes that will serve you well for many different types of work.

A text written on a single sheet of paper must appear to float comfortably in the available space. It's not as difficult as you may think to judge the correct proportions for your layout. Just follow these steps:

1. Measure the length and breadth of the paper or board on which you intend to write, and add the two figures.

2. From the resulting figure, subtract the measure of the diagonal.

3. Divide *that* resulting figure by 12.

You now have a unit for calculating margins. Allow 2 units for the top margin, 3 for each side margin, and 4 for the bottom one. You will see that the bottom margin is twice as wide as the top one, and the side margins intermediate in breadth between the top and the bottom.

This is a well-proportioned vertical layout. The bottom margin is twice as wide as the top one, and the side margins are in between those two easurements—$1\frac{1}{2}$ times the width of the top margin.

Although this formula leaves barely half of the surface available for writing, you should not make the margins any narrower. If space permits, or if the work is to be framed, wider margins may be used. You can also, if you wish, make the top margin and the side margins equal, provided that you increase the bottom margin to maintain the two-to-one proportion.

A centuries-old idea of proportion is known as the *golden section*. It goes back at least to the fifth century B.C., when architects designed the Athenian Parthenon according to its principles. Reduced to its simplest terms, the golden section produces a rectangle that has its short and long sides roughly in the proportion of five to eight—this is a *golden rectangle*. Once constructed, this rectangle can be reduced or enlarged by projection along a diagonal of the rectangle. The angle formed by the diagonal to the long side of the rectangle is 31.5°. You can use a protractor to determine the angle. As shown above, you can then produce a golden rectangle as large or small as you like. Another standard and pleasing proportion is three to four. One of these two classic shapes will serve for almost any calligraphic design, and both are recommended for your use.

$1 \frac{15}{16}$

$1 \frac{1}{2}$ $\frac{3}{4}$ $\frac{3}{4}$ $1 \frac{1}{2}$

$2 \frac{3}{4}$

A double-page spread in a bound book has narrower margins at the center, or gutter, than on the outer edges of the pages.

Margins on the pages of a book are symmetrical by spread (the two pages that you see when the book is opened and lies flat) rather than by single pages. Verso (left-hand, even-numbered) pages are laid out with the columns of text quite close to the center, or gutter. Recto (right-hand, odd-numbered) pages are mirror images of the verso pages. Fly (outside) margins and bottom margins are wider than the top margin. This allows you to hold the book, read, and turn the pages without your hands getting in the way of the text. This tradition has been carried over from the days when books were handwritten, and also applies to other layouts, such as pieces for framing. You will see this demonstrated in the following pages. You may wonder why Asian art differs from this tradition, with the layout placed low on the page under a wide *top* margin. It is because in Asia, most writing was originally intended to be rolled from the bottom, as a scroll, rather than bound in pages European-style. Both systems are logical and effective, but belong to different cultures and writing systems.

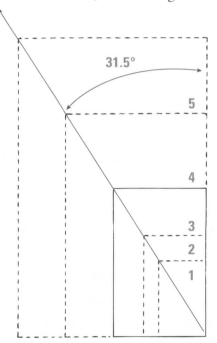

Once you have established the 31.5° angle of the golden rectangle (see below) you can make a similarly proportioned rectangle as large or as small as you like.

A GOLDEN RECTANGLE in the proportion of 5 to 8—the shorter sides are $\frac{5}{8}$ the length of the longer sides in this classic shape.

This is a well-proportioned single-page horizontal layout. The mortised initial and the center rubrication are optional but striking details. The margins are comparable to those of a single-page vertical layout.

Learning how to make artistic decisions is just as important to a calligrapher as studying the correct individual strokes and shapes included in the letters.

A rectangle in the proportion of 3 to 4, with the shorter sides $\frac{3}{4}$ the length of the longer sides, also provides a well-balanced frame for a piece of writing. It works equally well for a horizontal or a vertical layout.

Here are some practical applications for your new calligraphic abilities. The "good news" and birth announcement pieces show the front and the inside, respectively, of a typical greeting card. Similar layouts are suitable for any occasion. All kinds of labels for jars, boxes, drawers, and even rooms and apartments can be made in any size or shape and reproduced on copying machines. Several examples are shown here. The ornamental J on the grape jelly label on the next page might be done in several colors with, for example, felt markers. The fine scrolling may be done with a fine pen, a sharp colored pencil, or a ballpoint pen.

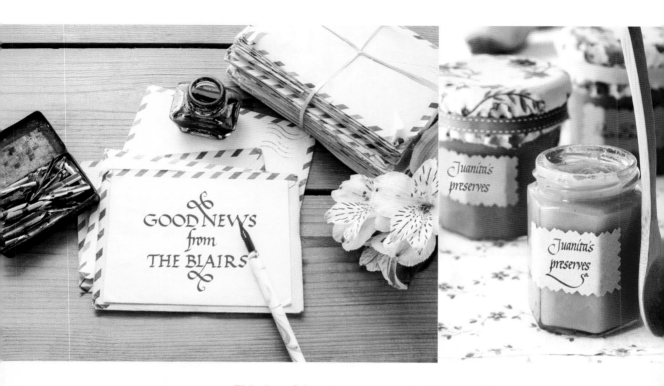

This is a CJ monogram used with a symbol. It could stand for Cathedral of St. James, or Church of St. John, with the cross helping to symbolize a church identity. Without the "St." and the cross, it could stand for Carol Jean, or Chris Jensen, and a different symbol or initial could be placed in the center. Similar monograms may be invented for persons, businesses, clubs, and so on.

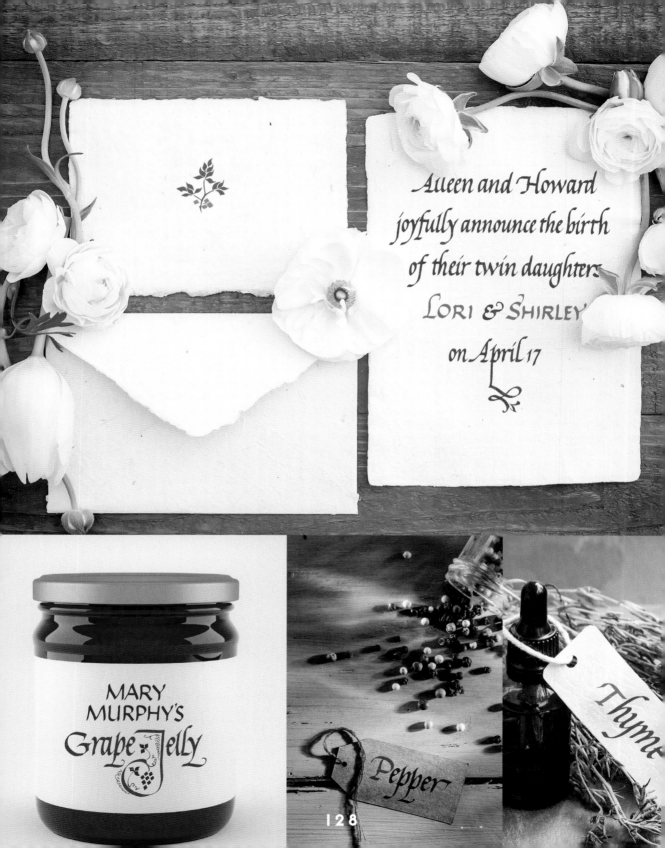

Aileen and Howard joyfully announce the birth of their twin daughters LORI & SHIRLEY on April 17

MARY MURPHY'S Grape Jelly

Pepper

Thyme

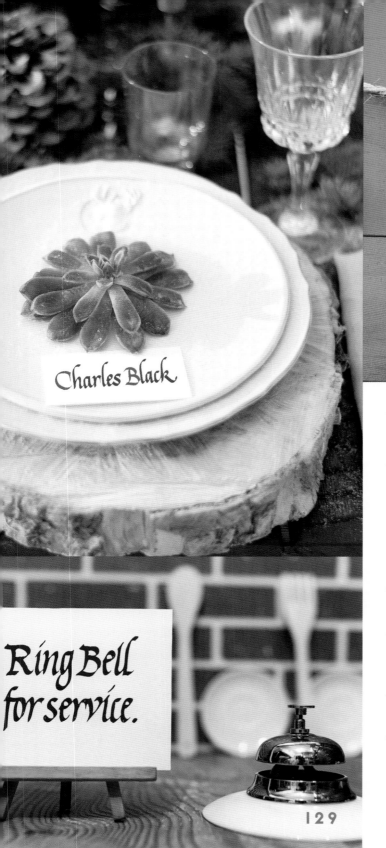

Charles Black

Ring Bell for service.

FARM-FRESH
EGGS
& TOMATOES

JACK & ELLIE JACKSON · 93 RED LINE ROAD

The layouts show a **PLACE CARD FOR A DINING TABLE** to the left and a **SIGN OR ADVERTISEMENT** (top). These may be made in any convenient size. Very large letters can be made with special writing instruments available from artist' supply stores.

The **EASEL CARD** to the left can be made as large or small as you like, to stand on a desk or countertop. Keep the message brief and to the point, and the size appropriate to the situation. The message can't be read if it's too small, and it won't be read if it's too wordy.

If you have read this book carefully to this point, and have followed the instructions and examples that it offers, you should now have a very good understanding of how the broad pen functions and how you can control it to get the most effective results. Although you're not yet producing polished Italic calligraphy, you should know that you've made—and are still making—measurable progress. You can be confident, then, that this progress is a permanent condition and that soon you'll be able to look back at this period as a time when you felt good about your ability, and from which you went quickly on to other things.

When you do feel ready to try other alphabets, such as Gothic, Carolingian, or Uncial for example, remember the way in which this book introduced you to Italic. Approach your new ventures in the same way you approached the Italic hand in this book.

Remember particularly the method of study embodied in *The Rule of Letters*. It will always be effective and it will, in the long run, be the quickest method of mastering broad-pen characters in any style. Select a *good* example of the new style you wish to master. Look at several versions in the library or at the bookstore. There are many "calligraphy" books on the market and many teachers of calligraphy. Some of the books are very good, and some are not so good; the same may be said of the teachers.

"Anno Domini 1983"—This decorative cypher was made with single strokes of the broad pen. The tendrils were made by dragging the nib on one corner; the thin lines required rotation of the writing paper. Although this design looks very free-flowing and spontaneous, it is the result of careful planning, much repetition, and perseverance. The scribe made about 20 sketches before achieving the final harmonious design. Like music, calligraphy must flow and look free and easy, but much hard work lies behind the finest examples of the calligrapher's art.

After reading and studying this book, however, you will be able to separate the good from the mediocre and make an enlightened choice either of a text to learn from or a teacher with whom to continue.

Begin with a simple version of each style; don't, for instance, choose to start with a Gothic alphabet that has lots of curly lines and hairline embellishments. Pay close attention to the pen angles and line weights for each style. (Pen angle and line weight are dependent on one another, remember.) Compare your work with that of other good calligraphers and try to incorporate into your own writing the best features of all of them. In spite of the many styles of calligraphy that you will encounter, certain rules of consistency and restraint govern all good writing and lettering—and these are the rules you've learned from this book.

These are three signs of the zodiac designed by the author. They represent the result of much thought and practice and were not very impressive in their early versions. Study the weight of the lines to determine the pen angle for each, then try your hand. Later you can try designing your own version.

NOTE: Do the lion's right eye and ear first (that's the one on your left as you look at it). That way you can see them clearly while drawing the other eye and ear to match.

GLOSSARY

ACUTE-OBLIQUE NIB
Pen nib bent into a curve, with an angled chisel edge that has the left side shorter than the right. For use by left-handed scribes.

AIR
Term used to describe white space in and around letters.

AMPERSAND
Sign meaning and, like this &. Derived from the Latin et.

ARCH
A stroke from the bottom of one picket to the top of another one, and including the second picket.

ARM
A basically horizontal stroke attached to a vertical; e.g., the three parallels in the capital E. Also sometimes called a rung.

ART GUM ERASER
A soft, crumbly eraser for cleaning art work.

ASCENDER
Part of a letter that extends above the waistline, as in h, l, or k.

ASCENDER LINE
Guideline, drawn or mentally envisioned on the page, beyond which the ascenders of letters should not extend. (See Guidelines.)

BARB
Another term for the pointed bird's head, as seen in i, j, and p.

BARREL
The body of the pen. In a fountain pen the barrel contains the ink reservoir or cartridge.

BARREL ANGLE

The angle at which the body of the pen is held in relation to the writing surface. In Italic the correct angle is about 45°.

BASELINE

The line upon which the small letters stand and below which their descenders extend. (See Guidelines.)

BIRD'S HEAD

An imaginative term for a characteristic feature of most of the Italic minuscules.

BRANCHING

One manner in which an arch or scoop meets or departs from a vertical.

BROAD PEN

A traditional writing instrument required for Italic and other calligraphy. The end of the nib is broad, or chisel-shaped, to permit both very broad and very thin lines to be made when the nib is moved in specific directions.

BROW

The top end of the arcs of the capital C and G.

BOWL

The closed body enclosing the counters of such characters as b, g, and p.

CALLIGRAPHY

Beautiful or elegant handwriting. From the Greek words for beauty and to write. A standard definition used by scribes is: "writing considered as an art."

CAPITAL

Large letter; also called majuscule.

CARTRIDGE

Container of ink that fits into the barrel of many brands of fountain pens. An alternative to filling the pen from a bottle of ink.

CHANCERY ITALIC
A writing style developed in Renaissance Italy and employed by scribes of the Vatican chancery.

CHECKERBOARD
Design made with the edge of the nib to measure guideline intervals and letter height for a specific nib size. Italic guidelines are usually $4\frac{1}{2}$ to 5 pen widths apart.

CHISEL EDGE
Squared-off, sharp writing edge of broad-pen nib.

COLOR
Degree of blackness, or weight of writing. Color depends upon proportions of pen widths and heights and condensation of the letters.

COUNTER
A space within a letter; e.g., the hole in the o; the spaces between the rungs of E.

CURSIVE
"Running," i.e., written with a minimum of pen lifts.

CROSSBAR
The horizontal stroke of f, t, or T.

DESCENDER
Part of a letter that extends below the writing (base) line, usually ending just short of the descender line; e.g., the tails of j, p, q, or y.

DESCENDER LINE
Guideline, drawn or mentally envisioned on the page. Descenders usually end just short of this line. (See Guidelines.)

DIP PEN
A pen that has no large reservoir to hold the ink (as does a fountain pen), and must be dipped repeatedly into the ink. Modern equivalent of the cut quill or reed historically used as writing instruments.

DOTS
Identifying marks over i and j. In Italic writing these are usually short angled lines rather than dots.

DOUBLE LETTERS
Letter combinations in which a pair of ascenders or descenders present special problems; e.g., ff, ll, tt, pp. In such combinations one of the pair is modified to produce a more pleasing appearance.

EXTENDER
Any part of a character that projects above or below the main body or beyond the waist or baselines. This includes all ascenders and descenders, and certain angled and horizontal elongations.

FLAG
The horizontal extremities of the typical Italic ascenders and descenders.

FLOURISH
Stroke made longer, larger, or more intricate than usual as decoration or filler.

FOLDED RIBBON
The effect imparted by the movement in different directions of a broad pen held at a consistent angle of 45° to the writing surface. This effect can be seen in individual letters as well as in ornaments.

GUIDELINES
A series of lines, drawn or mentally envisioned on the page, to assist the scribe in maintaining the correct letter proportions. Bodies of letters are made between the base or writing line and the waistline; the ascender and descender lines are, respectively, above and below this area. In Italic writing these four guidelines are usually equidistant and spaced about $4\frac{1}{2}$ to 5 pen widths apart.

GUIDE SHEET

A loose sheet with ruled guidelines, placed under a sheet of writing paper to guide the writing so that it's not necessary to rule (and subsequently erase) lines on the writing paper itself. To be used only with lightweight paper.

HORIZONTALS

Strokes made approximately parallel to the writing or baseline. In the Italic hand shown in this book horizontals are understood to have a slight downward slant to the right.

ICE-SKATE STROKE

Thin line made by moving the broad pen, held at a 45° angle, from lower left to upper right or vice versa. This is the finest line that can be made when the pen is held at the correct angle.

INITIAL

Large capital letter, often flourished or ornamented, used to draw attention to the beginning of a piece of writing or to a new idea or paragraph.

JOINS

Strokes linking letters in a word; sometimes called ligatures. Italic writing is traditionally joined, if not actually written cursively.

LEFT-OBLIQUE NIB

Pen nib cut on an angle so that the left side is shorter than the right. For use by left-handed scribes.

LETTERSPACE
Distance between letters in a word. Letters should appear to be equidistant from adjacent letters.

LIGATURE
Stroke joining one letter to another in cursive or joined writing. (See Joins.)

MAJUSCULE
Large or capital letter; THESE ARE MAJUSCULES.

MINUSCULE
Small letter; these are minuscules.

MORTISE
A space in a block of copy into which is inserted an initial, illustration, or other embellishment.

NIB
Steel writing point of the pen; based on the prepared and cut quills or reeds historically used as writing instruments.

NIB ANGLE
Angle of the nib edge in relation to the writing line. In Italic the correct angle is about 45°.

NON-WATERPROOF INK
Ink that, after use, remains susceptible to moisture and will run or smear if in contact with moisture. To avoid clogging, fountain pen inks are not waterproof.

ORNAMENTATION
Decoration of writing with designs and flourishes, sometimes in color.

PEN WIDTH

Breadth of the writing edge of the broad-pen nib. Pen width determines correct letter height. In Italic writing the bodies of small letters are about $4\frac{1}{2}$ to 5 pen widths high.

PICKET

Name given to the straight vertical stroke, slanted slightly to the right, that is a characteristic feature of the Italic manuscript alphabet. "Picket fence" describes the pattern made by a succession of these strokes, like this—///////////.

PRESSURE

Degree of force exerted by the pen against the paper during writing. It's always minimal.

PRINTING

Making an impression on a surface with a device such as a rubber stamp, typewriter, or printing press. Letters made by hand are not printed, they are written—no matter how neat or blocky they are.

RESERVOIR

Container in the body of the fountain pen that holds the ink.

ROMAN CAPITALS

The capital letters of classical Rome from which all our writing hands and typefaces have evolved.

RUBRICATION

The making of certain words or letters in red to differentiate them from the body of the text and to beautify an inscription. From the Latin for red. Other colors may be used also, but red is traditional and most effective; it should be a light, fiery vermilion.

RULES

Pencil lines drawn on the writing paper to guide the scribe, then erased from the completed work. If the writing paper is translucent, a ruled guidesheet can be slipped underneath it to avoid having to mark the writing surface.

RUNG

A horizontal stroke as in A, E, or H.

SCOOP

An inverted arch shape. A standard connecting stroke between vertical components of letters and a standard means of joining letters.

SCRIBE

Literally, a person who writes. From the Latin for to write. The term used to denote an official writer; now used to describe a calligrapher.

SERIF

A thickening, crossbar, or other treatment of the end of a letter stroke.

SKELETON

The basic shape of a letter as traced by the center of the broad nib.

SLANT

Degree to which writing leans to the right. In Italic writing the recommended slant is between 5° and 8° and must be consistent throughout any piece of writing.

SLIP SHEET

A sheet of paper placed beneath the heel of the writing hand to protect the writing paper from the skin's oils and moisture.

SNOWPLOW STROKE

Stroke made by moving the edge of the broad pen, held at a 45° angle, horizontally or vertically. This stroke is broader than an ice-skate stroke but narrower than a squee-gee stroke, and gets its name from the angled movement of the chisel edge of the nib as it shaves along like a snowplow blade.

SPIKE

A very small, sharp point of a stroke that is allowed to extend beyond a stroke at right angles to it. Examples are the top of a, g, and q, and the bottoms of the bowls of b and p.

SPIKY
Writing in which the arches and scoops tend to become sharp, rather than rounded. This tendency should be avoided by beginners.

SPINE
Vertical backbone of a letter such as f, F, p, P, t, or T. Also called stem.

SQUEEGEE STROKE
Thick line made by moving the broad pen, held at a 45° angle, from upper left to lower right or vice versa in the manner of a squeegee. This is the broadest stroke that can be made by the pen.

STAR
Diagram formed by a combination of ice-skate, snowplow, and squeegee strokes to demonstrate or to verify that the broad pen is held at a consistent 45° angle.

STEM
The vertical part of a letter such as f, F, p, P, t, or T. Also called spine.

TAIL
Descender of a letter, especially one that incorporates a flag or flourish; e.g., in j or y.

TENDRIL
Very fine, diminishing hairline produced by turning the nib on one corner and dragging the ink into a delicate curl or hairline. Used ornamentally.

THICKS
Broad strokes made by the pen's chisel edge. Usually referred to as vertical pickets.

THINS
The fine strokes made by the pen's chisel edge, particularly ice-skate connecting lines between verticals.

TRANSITION

All curving lines are transitional, becoming either thicker or thinner as the pen moves in different directions.

VERTICALS

Upright or nearly upright strokes. In Italic writing verticals are understood to slant slightly to the right.

WAISTLINE

Guideline, drawn or mentally envisioned on the page, to indicate height of the bodies of small letters. (See Guidelines.)

WATERPROOF INK

Ink that is not susceptible to moisture after use and therefore will not run or smear. Waterproof ink can be used with dip pens but is too thick and gritty for use in fountain pens. Note that the term waterproof may be misleading as applied to some inks.

WEIGHT

Degree of boldness of letters, or proportion of inked area to open background. Small writing done with a broad nib has more weight than larger writing done with the same nib.

WORDSPACE

Space between words in a line of writing. This should only be enough to suggest the separation of one word from another. Beginners tend to exaggerate this separation. If an n can be inserted comfortably between words, the space is probably excessive.

This Latin inscription means Love of Writing. If you practice diligently and are rewarded with regular improvement, you should develop an understanding and respect for calligraphy that you probably never anticipated in the beginning. In fact, you'll acquire a deep and lasting love of the art of beautiful writing.

The final pages of this book are ruled to the proportions of the examples given throughout the text. These ruled guide sheets are useful as reminders of the heights of various components of the minuscules, but constant use of guidelines fosters a dependency on them. The author prefers to have students develop a *feel* for the regularity of letter height and levelness of line, and this requires a lot of practice and effort. So, although the guide sheets are useful, don't let yourself be tempted to use them all the time. They're recommended for formal work only. At other times you should keep your mind on maintaining regular and well-proportioned letters and a straight line of writing. Don't insist, "I *can't* write in a straight line," before giving it your honest and persistent best effort. Before long you'll find you *can* do it.

The worksheets may be reproduced on a copier and the originals retained indefinitely, or they can be removed from the book and either used for practice, or copied before use. (It obviously makes more sense to keep the originals and practice on copies, but remember that if you're going to write on the copies you'll need them to be of a quality that will take the ink without bleeding.) If your writing paper is translucent, you can slip the guidesheet under it so that you have guidelines to work with but no tedious erasing of pencil lines to do later.

This illustration demonstrates the importance of matching letter height to nib width in order to produce well-proportioned letters. Top: The proper height for the nib width, compared with letters made too small and too large for the nib.

The results of writing with the nib at an angle that is too flat (left), and too steep (right).

The bodies and bowls of most letters rise to the level of the *waistline*. Nearly all letters stand on the *baseline*. Most ascenders reach the *ascender line*, which is also the descender line for the preceding line of writing. Most descenders reach the *descender line*, which is also the ascender line for the line of writing to follow. The capitals (except for swash versions and certain flourishes) are held by a fifth line, the *capital line*, to about six pen widths in height. The capital line need not be drawn, as its level is easily established in relation to the waist- and ascender lines.

Remember to pay attention to your margins at all times, keeping them generous and as regular as you can. This is another responsibility of the scribe, who must not only execute correct writing but also organize and present it in an effective and inviting way.

These guidelines have been drawn for use with the Platignum Italic broad nib used to make most of the smaller letters in this book. The distance between them is 4½ to 5 times the width of the pen nib. If you're using a different pen, check that the distance is correct by making the checkerboard pattern shown here and in the chapter on spacing.

ASCENDER LINE
WAISTLINE
BASELINE
DESCENDER/ASCENDER LINE
WAISTLINE
BASELINE
DESCENDER LINE

These guidelines have been drawn for use with the Sheaffer NoNonsense®
B nib used to make most of the larger examples shown in this book. The
distance between them is $4\frac{1}{2}$ to 5 times the width of the pen nib. As with the
previous guide sheet, make a checkerboard pattern to be sure the guidelines
are correctly spaced for the pen you are using.

ASCENDER LINE

WAISTLINE

BASELINE

DESCENDER/ASCENDER LINE

WAISTLINE

BASELINE

DESCENDER LINE